THE THEATER OF INSECTS

THE THEATER OF INSECTS

Photographs by Jo Whaley

Essays by
Deborah Klochko, Linda Wiener,
and Jo Whaley

CHRONICLE BOOKS
SAN FRANCISCO

— *FOR GREG* —

"Spectacle of Nature" copyright © 2008 by Deborah Klochko.
"Philosophy of Insects" copyright © 2008 by Linda Wiener.
"Notes from the Studio" and photographs copyright © 2008 by Jo Whaley.
All rights reserved. No part of this book may be reproduced in any form
without written permission from the publisher.

Library of Congress Cataloging-in-Publication Data available.

ISBN: 978-0-8118-6155-7

Manufactured in China

DESIGNED BY BRETT MACFADDEN & JO WHALEY

10 9 8 7 6 5 4 3 2 1

Chronicle Books LLC
680 Second Street
San Francisco, California 94107

www.chroniclebooks.com

TABLE OF CONTENTS

Spectacle *of* Nature
BY DEBORAH KLOCHKO
7

Plates
13

Philosophy *of* Insects
BY LINDA WIENER
109

Notes from the Studio
BY JO WHALEY
121

List *of* Illustrations
126

Acknowledgments
127

Contributors
128

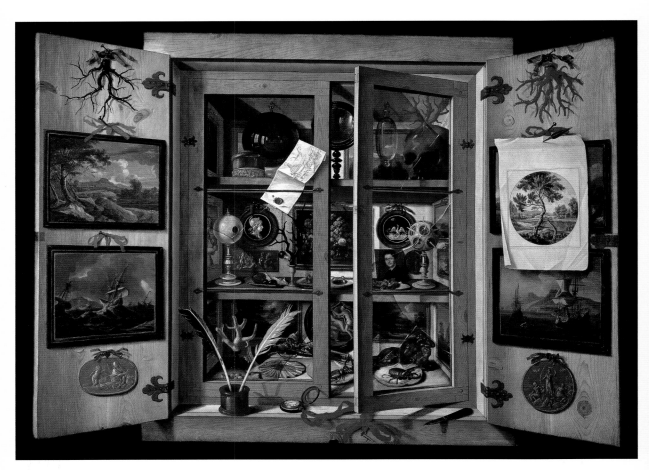

FIGURE 1

SPECTACLE OF NATURE

BY DEBORAH KLOCHKO

"... *every art should become science, and every science should become art*..."
—FRIEDRICH VON SCHLEGEL, 1797

The stage is set, the curtain rises, and the audience watches a show unlike any other. By reinterpreting the concept of scientific study within the framework of artistic interpretation, photographer Jo Whaley transforms the world of insects into elaborate creations that draw upon both the rational and the creative aspects of the human compulsion to gather and study nature. In her photographs, art and science come together in a seamless partnership much like the *Wunderkabinettes*, or curiosity cabinets (FIGURE 1), of the sixteenth through nineteenth centuries. "Encyclopedic collections of fantastic and useful objects—minerals, shells, bizarre animal specimens, marvels of human art and science, clever machines, amazing toys.... These diverse artifacts made the active process of relating visible as they reached out to one another to create new pairings."[1] Whaley's work is a personal "cabinet of curiosities" that combines her instincts as a collector with her training as a scene painter for the theater.

Whaley calls her creations "photographs of narrative fiction." They have antecedents in scientific illustration that go back to the Scientific Revolution of the sixteenth and seventeenth centuries. At that time, a new approach to science emerged that relied on experimentation and direct observation of nature rather than on ancient knowledge. New explorations into perception and optics gave artists the tools to more accurately document these exciting findings. From his observations through the microscope, Robert Hooke, in his 1665 book *Micrographia*, wrote about the strength and beauty of fleas. Much of the book's popularity was due to his inclusion of detailed illustrations based on what this new tool of science allowed him to see (FIGURE 2).

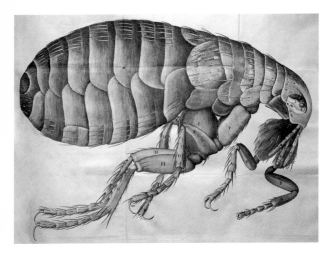

FIGURE 2

FIGURE 4

FIGURE 3

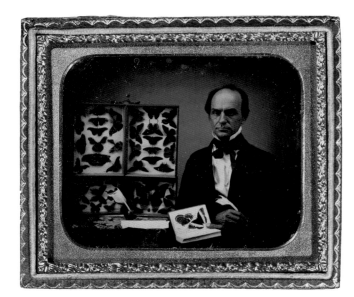

FIGURE 5

With this newfound precision, aesthetic considerations figured prominently in the creation of scientific illustrations. Many of the conventions of artistic creation—posing, placement, context, and color—were incorporated into scientific renderings. Whether viewed aesthetically or to gather information, these plates illuminated what could have been a very tedious cataloging of information. The fifteenth-century introduction of methods of mechanical reproduction—first woodcuts, then engravings (FIGURES 3 & 4)—allowed for visually rich publications in Europe.

The authenticity of scientific illustrations was unequaled until the emergence of photography in the 1830s. Photography, based on studies in light, optics, and chemistry, offered a new tool that was immediately embraced by both artists and scientists. "The taking of a scientific picture inevitably involved making aesthetic choices, judgements, and interventions."[2] The authority of the photograph helped validate it as an ideal means of representing nature (FIGURE 5). Even the terms used to describe the making of a photograph—taking, capturing—were the same as those used for the gathering of natural specimens.

By 1843, William Henry Fox Talbot, the English inventor of one of the first photographic processes, used the camera as a collecting tool in his pursuit of the natural world. Capturing the wing of an insect with his camera (FIGURE 6), he demonstrated the possibilities of his new process, which he called "light writing" or "photogenic drawing." Talbot's French counterpart in the invention of photography, Louis-Jacques-Mandé Daguerre, gathered fossils as carefully as any scientist in some of his early images. "Early photographers were involved in a partnership with nature, and at the same time they were artists familiar with traditions of picture making."[3] The first published use of photography for scientific illustration was in 1843, in the book *British Algae: Cyanotype Impressions* by Anna Atkins. Her photographs were not made with a camera, but accomplished by placing specimens in direct contact with light-sensitive paper (FIGURE 7). The images were printed by the action of the sun, then bound into limited-edition books.

While the century and a half since the invention of photography has seen a growing separation between art and science, Jo Whaley's work in *The Theater of Insects* takes us to the point of discovery provided by early scientific illustrations. By creating carefully crafted, theatrically staged

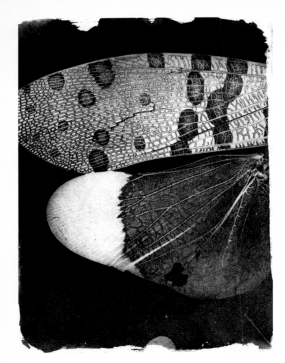 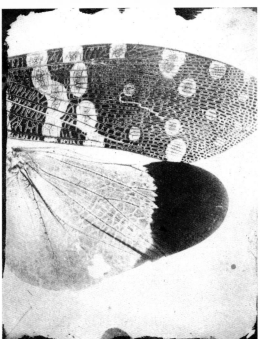

FIGURE 6

sets, Whaley invites the viewer to engage with the actors—in this case, insects—allowing their beauty to be seen in unexpected ways.

As a young artist, Whaley worked as a scene painter for the San Francisco Opera and Ballet and was head painter at the Zellerbach Playhouse at the University of California, Berkeley. Incorporating techniques from this experience, she constructs miniature stages with bits of nature as the performers. Approaching the gathering of materials as methodically as any scientist, she looks to the art of previous centuries for inspiration, working with camera, setting, and subject as intimately as a painter handles brushes and paint. With careful placement of illumination and the use of colored gels, Whaley is able to paint with light in every portion of the photograph.

In the age of computers, it is rare to find someone who so meticulously crafts her art. Working in the studio, Whaley constructs contained environments, staging elaborate tableaus of object and artifact for the camera. The final images have much in common with the Victorian penchant for presenting nature in descriptive settings. At that time, both artists and scientists had a fascination for exploring the natural world. The artistic

FIGURE 7

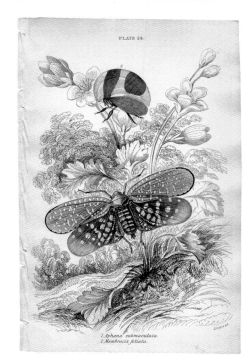

FIGURE 8

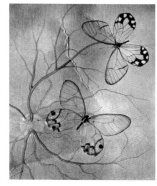

FIGURE 9

approach was not necessarily logical, but relied on an emotional response to the subject. Though scientists were often motivated by a love of nature, they needed to produce objective illustrations for research and study. It is clear that Whaley possesses a love of nature, but her approach is ultimately artistic. The stage she creates for each insect is meant to open the viewer's perspective, allowing associations that would not be likely to arise when viewing a purely informative image (FIGURES 8 & 9).

While making reference to science, Whaley's photographs guide the viewer into the realm of the imagination. In David Cronenberg's 1986 film *The Fly*, the titular main character states, "I'm saying I'm an insect who dreamed he was a man and he loved it, but the dream is over and the insect is awake." Jo Whaley's work awakens us to the insect, and we will never look at nature the same way.

1. Barbara Maria Stafford and Frances Terpak, *Devices of Wonder: From the World in a Box to Images on a Screen* (Los Angeles: Getty Publications, 2001), 6.
2. Jennifer Tucker, *Nature Exposed: Photography as Eyewitness in Victorian Science* (Baltimore: Johns Hopkins University Press, 2005), 159.
3. Ibid., 18.

PLATES

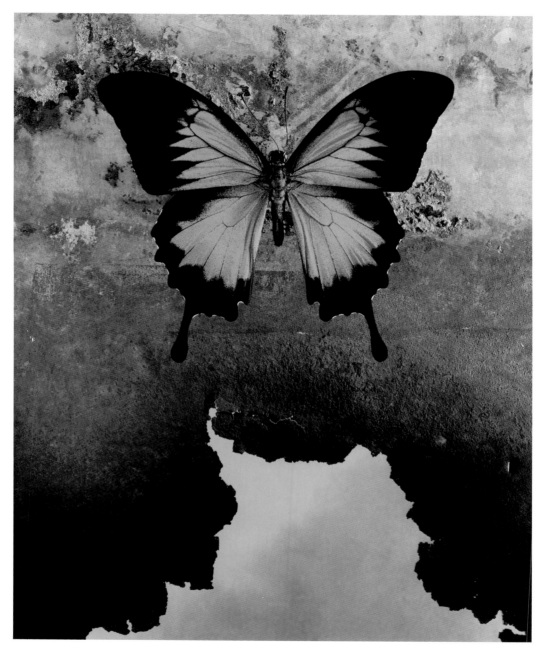

PLATE 1 *Papilio ulysses*

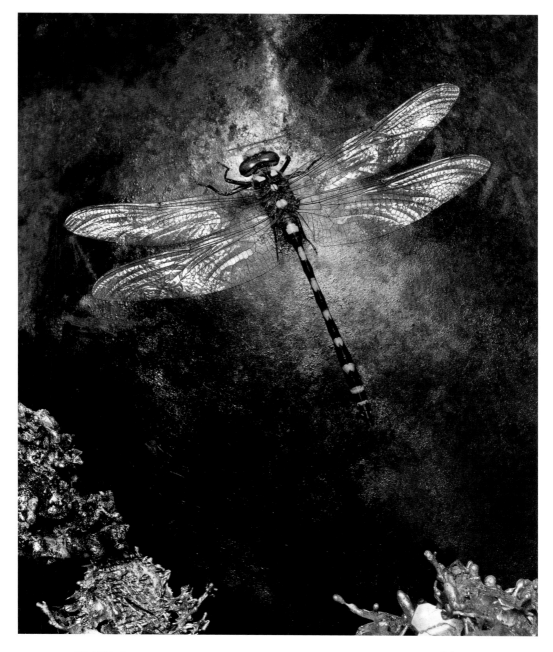

PLATE 2 Odonata

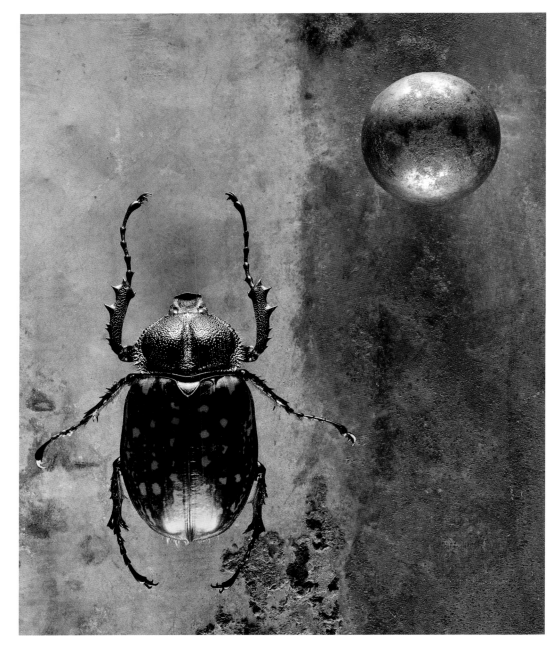

PLATE 3 Coleoptera

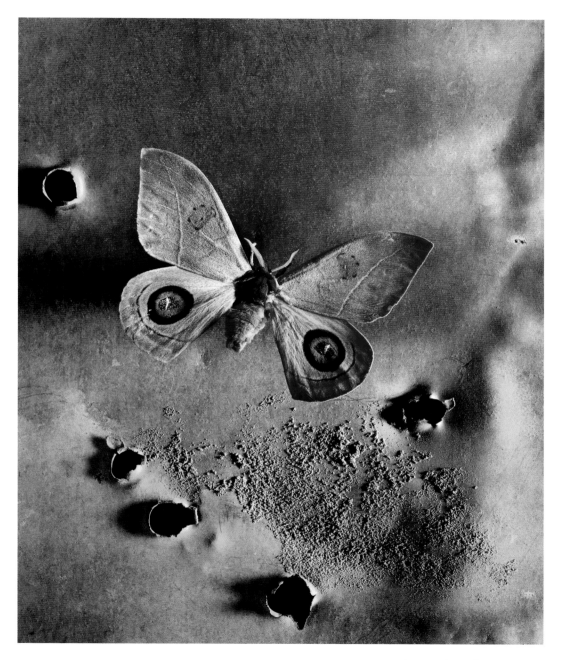

PLATE 4　　　　　　　　　　　　　　　　　　　*Automeris randa*

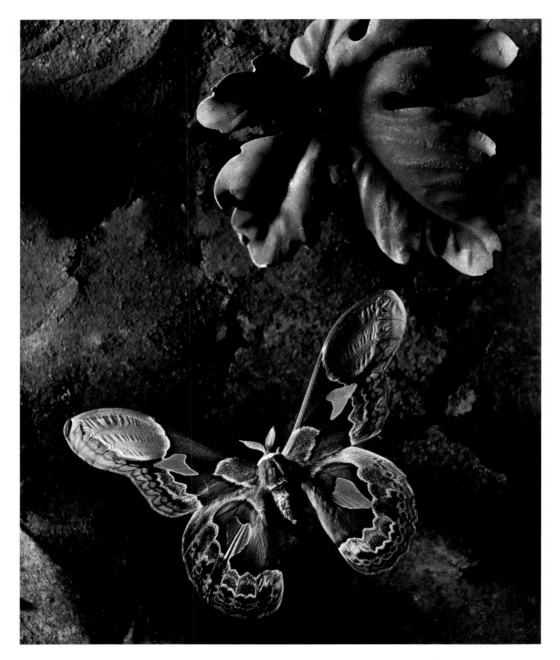

PLATE 5 *Rothschildia*

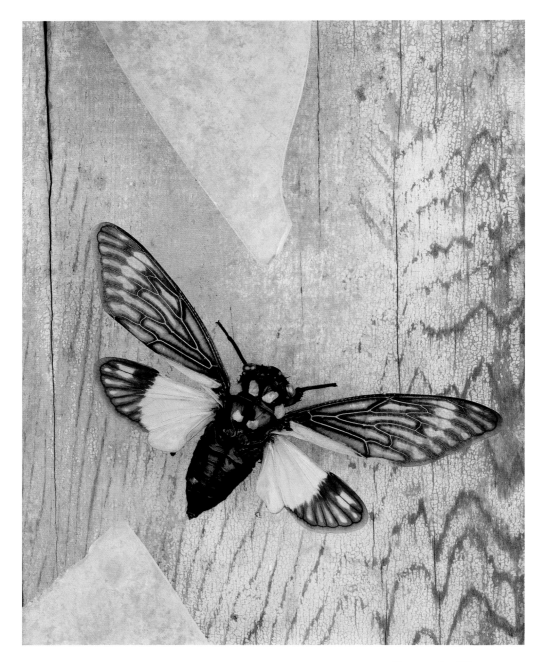

PLATE 6 *Tosena splendida*

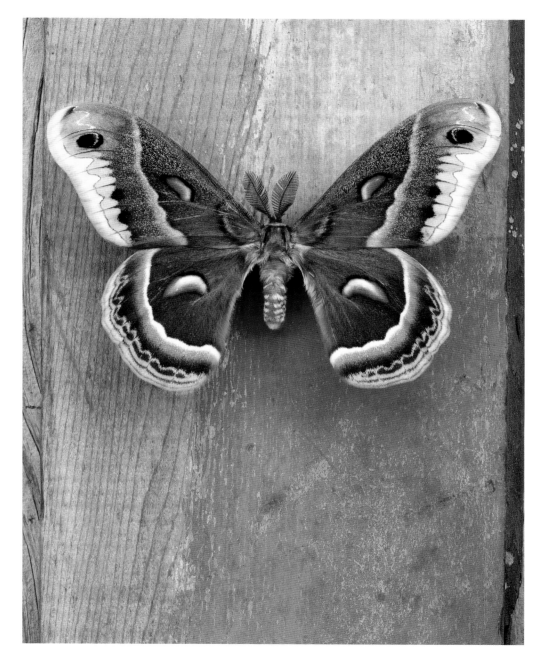

PLATE 7　　　　　　　　　　　　　　　　　　　　*Hyalophora cecropia*

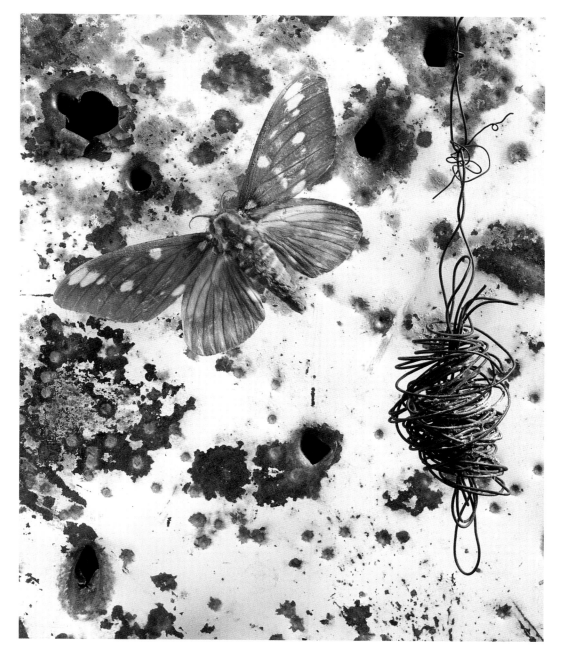

PLATE 8 *Citheronia regalis*

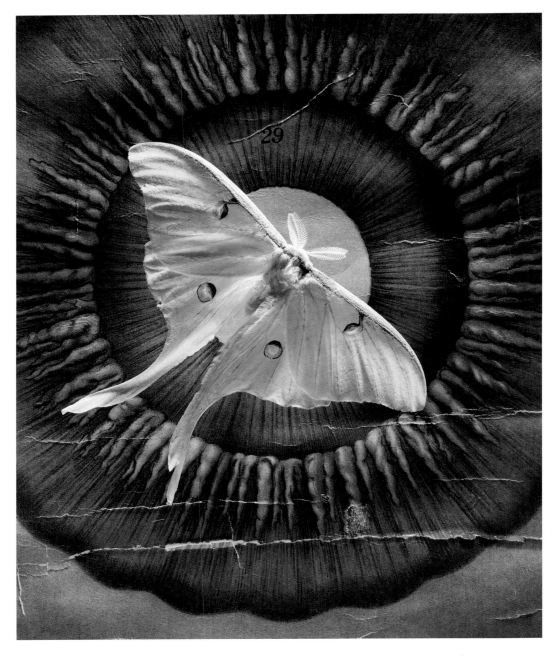

PLATE 9 *Tropea luna*

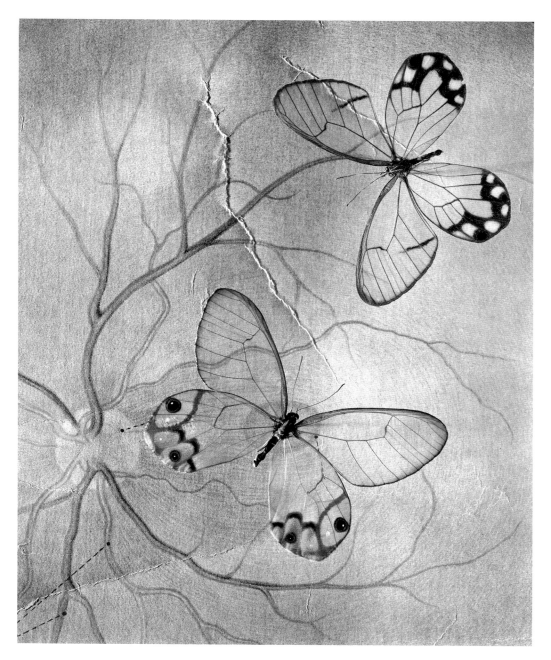

PLATE 10 *Cithaerias*

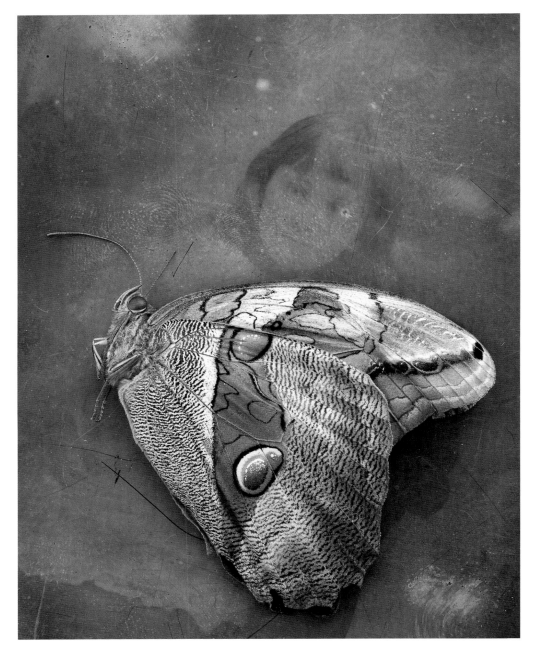

PLATE 11 *Eryphanis polyxena*

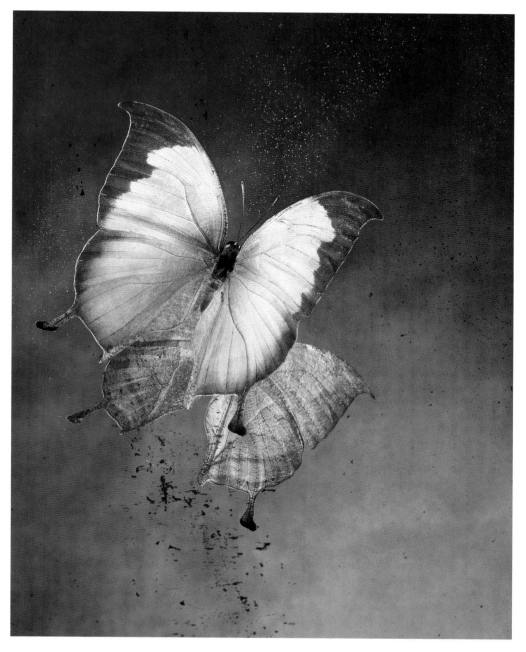

PLATE 12 Nymphalidae: *Charaxes*

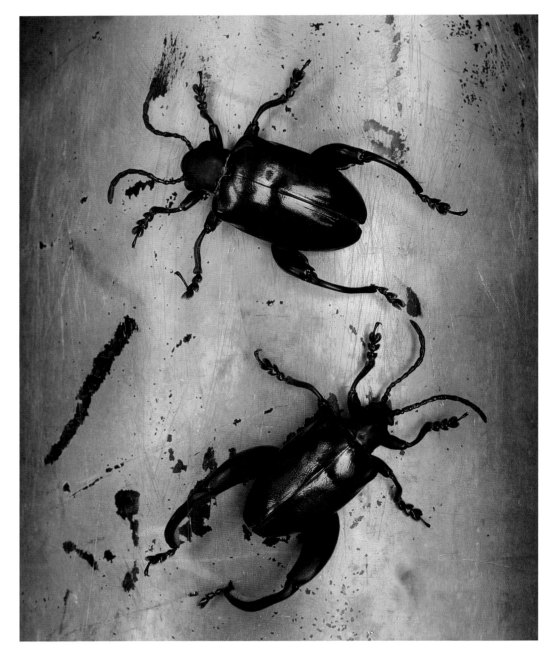

PLATE 13 *Sagra buqueti*

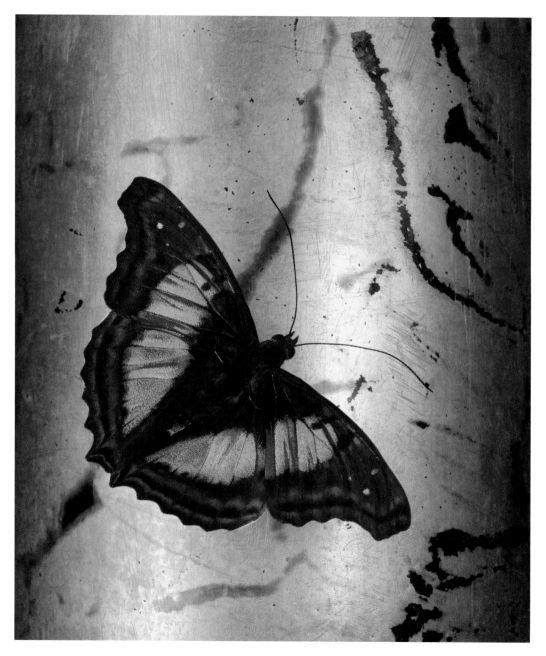

PLATE 14 *Doxocopa cherubina*

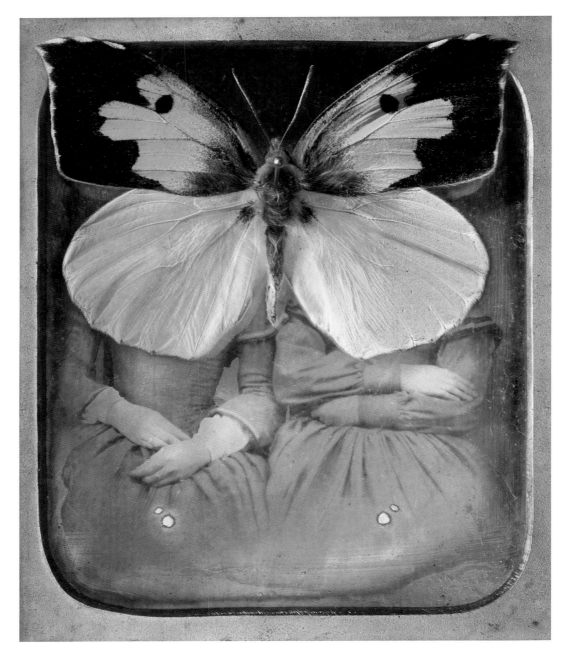

PLATE 15 *Colias eurydice*

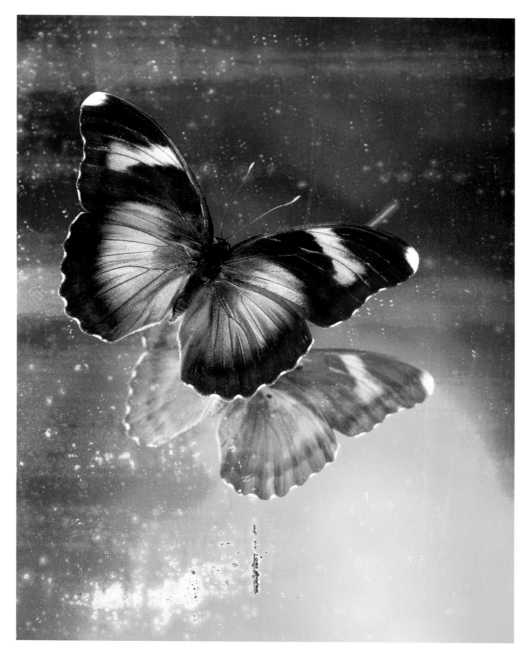

PLATE 16 Nymphalidae *Hypolimnas*

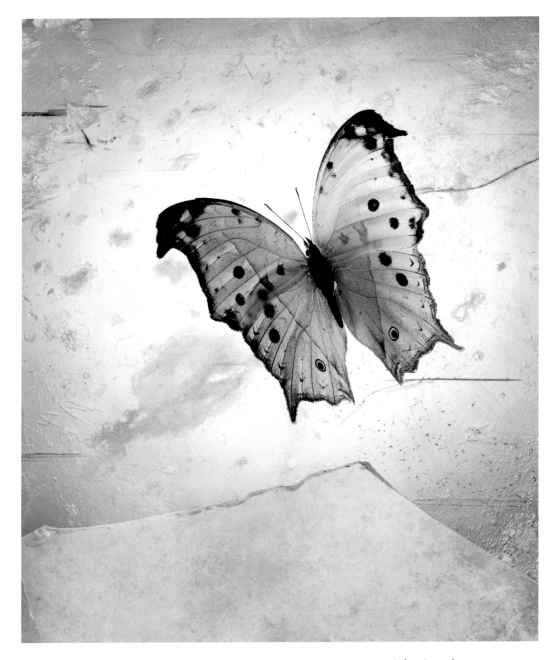

PLATE 17 *Salamis parhassus*

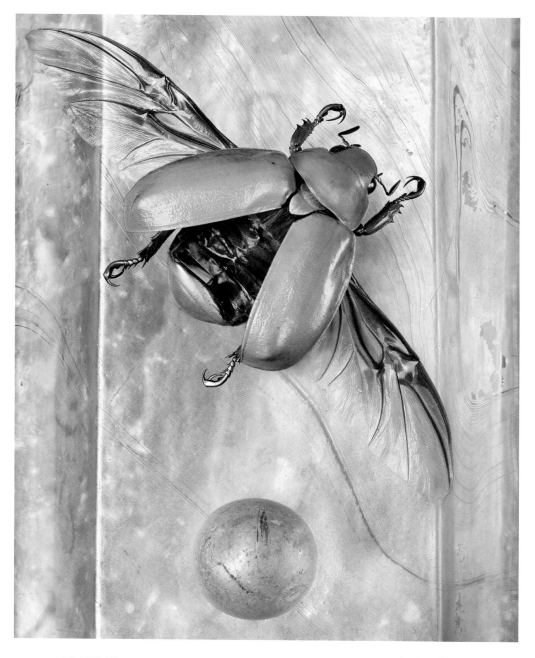

PLATE 18　　　　　　　　　　　　　　　*Plusiotis beyeri*

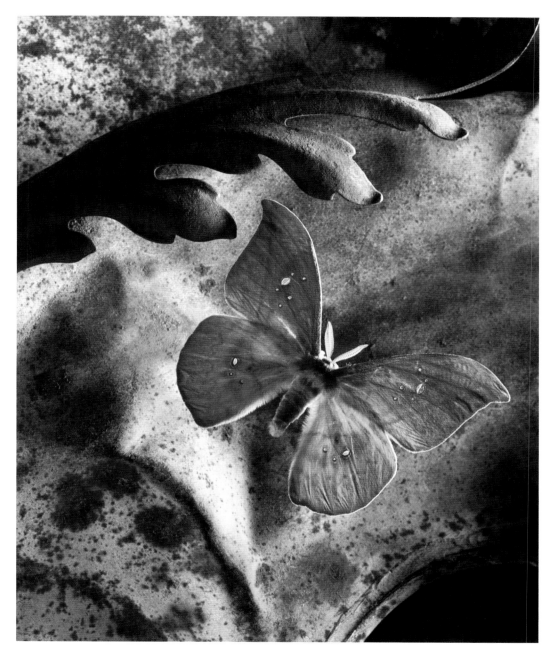

PLATE 19 Saturniid

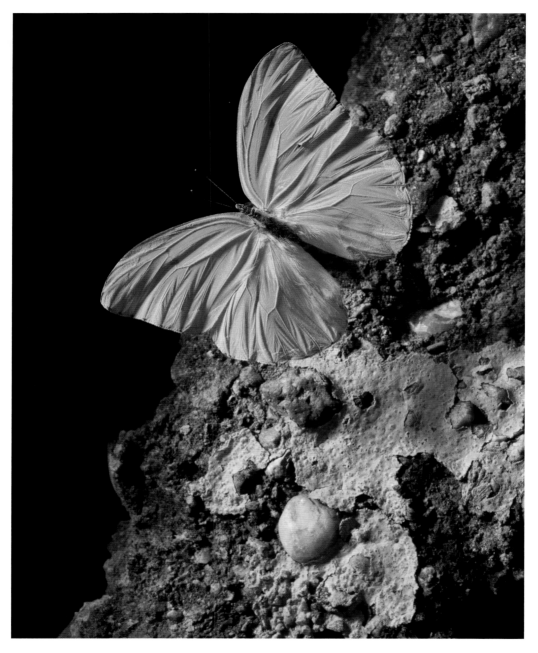

PLATE 20　　　　　　　　　　　　　　　　　　　　Pierid *Phoebis*

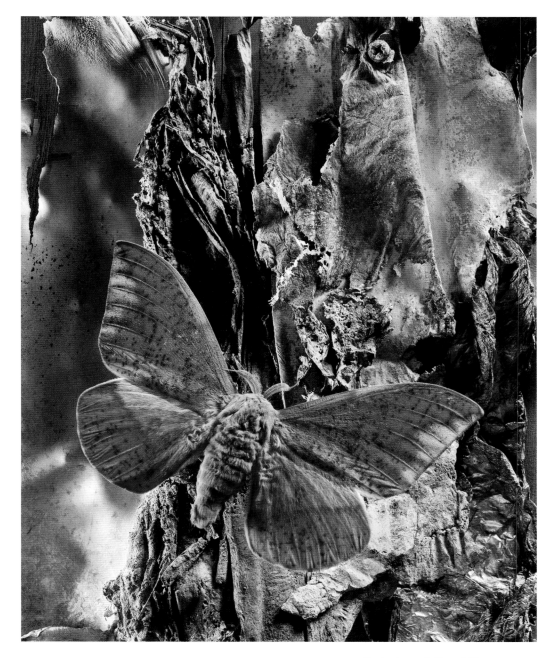

PLATE 21 *Eacles imperialis nobilis*

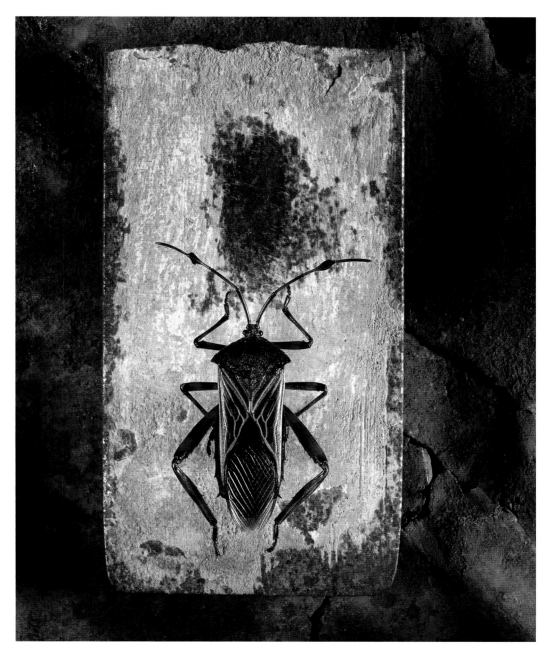

PLATE 22　　　　　　　　　　　　　　　　　　　　　　　*Thasus gigas*

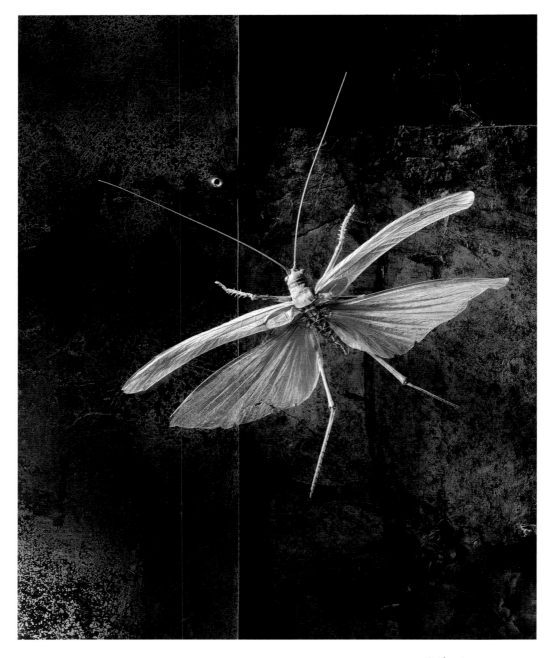

PLATE 23 — Orthoptera

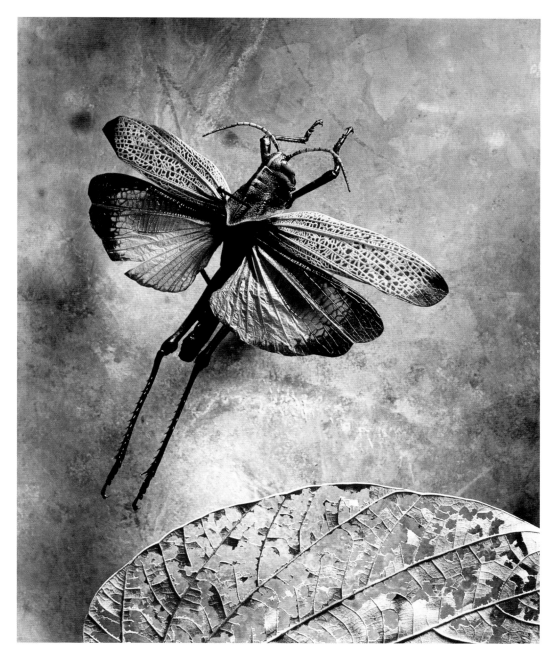

PLATE 24　　　　　　　　　　　　　　　　　Orthoptera: *Acrididae*

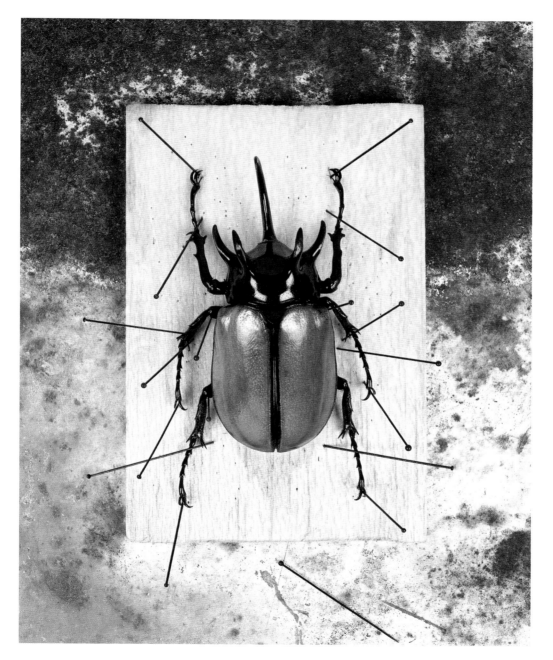

PLATE 25　　　　　　　　　　　　　　　　　　*Eupatorus gracillicornis*

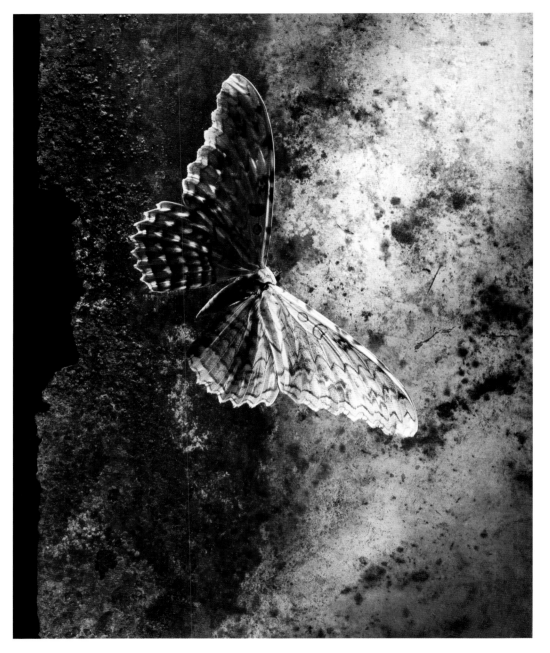

PLATE 26　　　　　　　　　　　　　　　　　　*Thysania agrippina*

PLATE 27 *Nymphalid*

PLATE 28 *Anaea cyanae*

Fig. 5. **Pelvis** hombre y de la mujer

PLATE 29 *Pareronia valeria*

PLATE 30　　　　　　　　　　　　　　　　　　　　Nymphalid

PLATE 31 *Diastocera wallichi*

PLATE 32 Lyropteryx apollonia

PLATE 33 *Idea leuconoe*

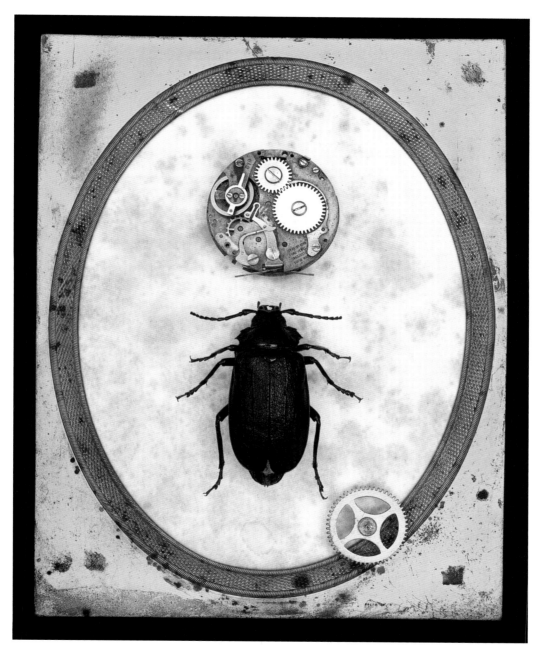

PLATE 34　　　　　　　　　　　　　　　　　　　　Coleoptera

Fig. 1. **Esqueleto del hombre** Fig. 2. **Esqueleto del mono**

PLATE 35 *Pyrops candelaria*

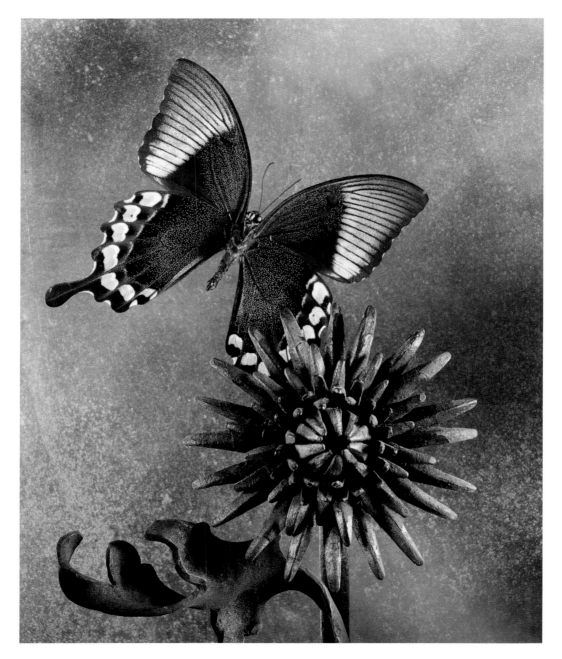

PLATE 36 *Papilio blumei*

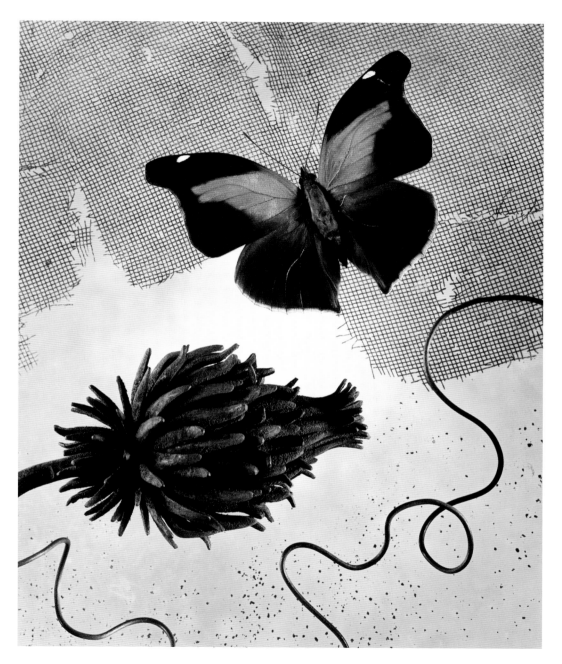

PLATE 37 Nymphalid

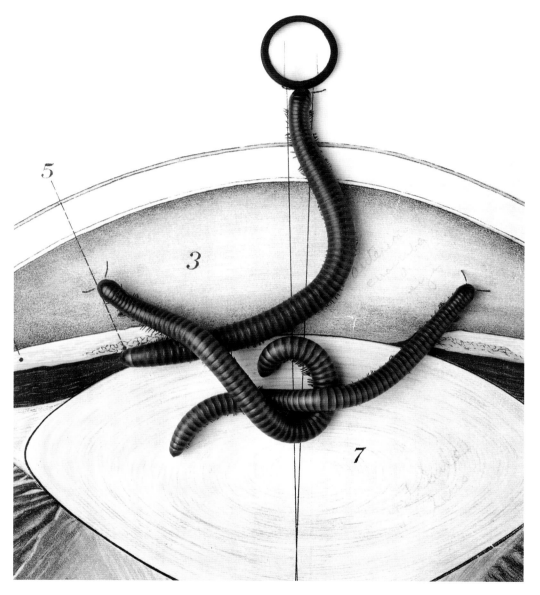

PLATE 38 *Narceus americanus*

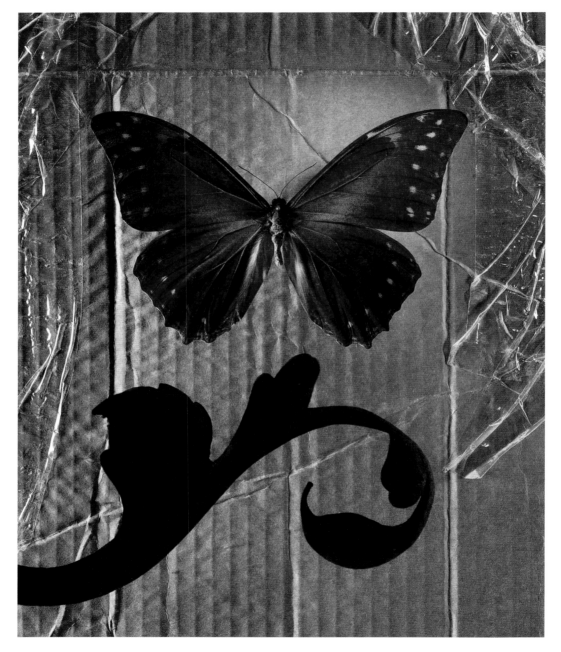

PLATE 39 *Morpho hercules diadema*

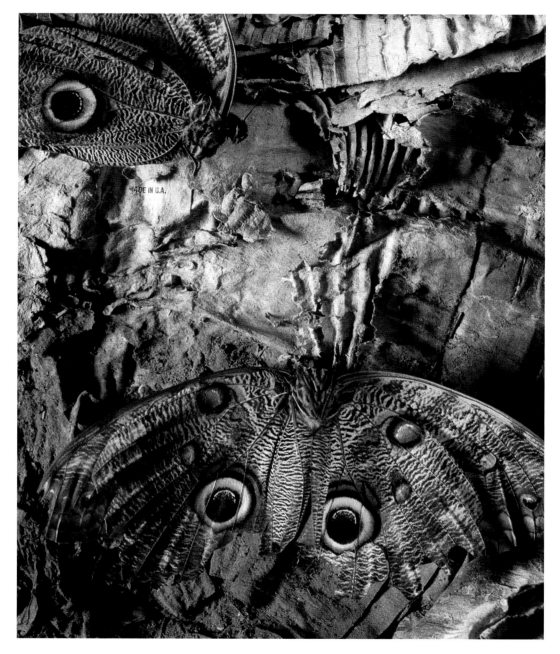

PLATE 40 *Caligo eurilochs*

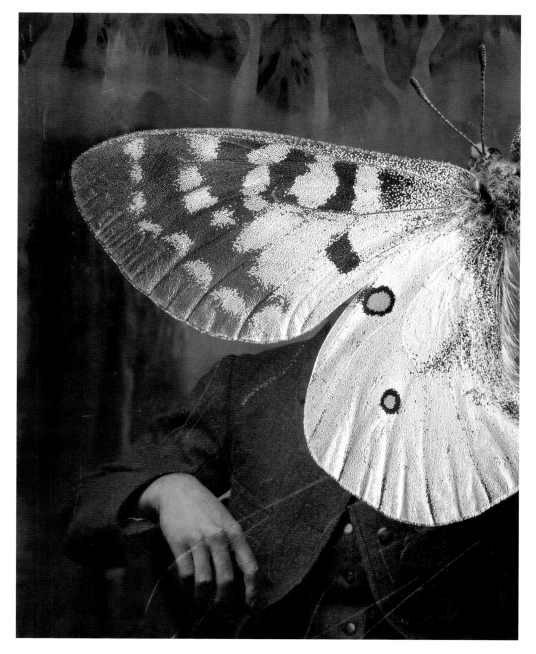

PLATE 41 *Parnassius apollo*

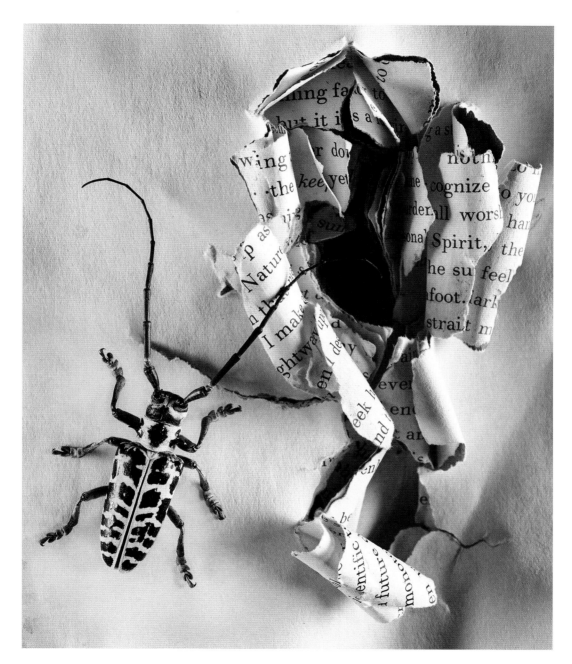

PLATE 42 *Plectrodera scalator*

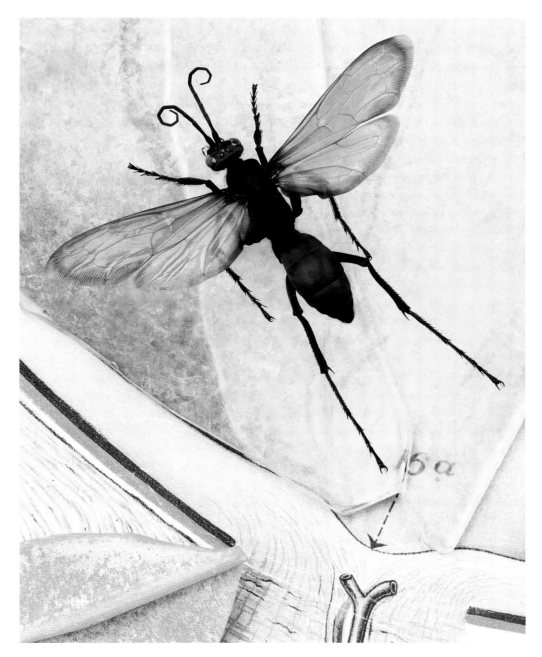

PLATE 43 *Pepsis formosa*

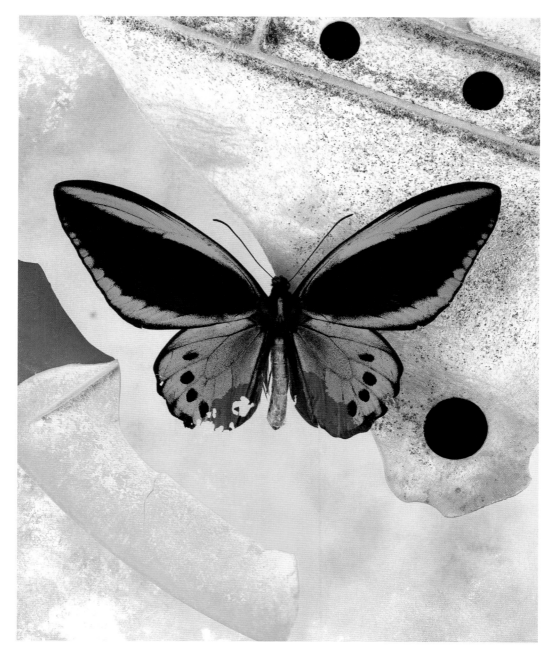

PLATE 44 *Ornithoptera priamus*

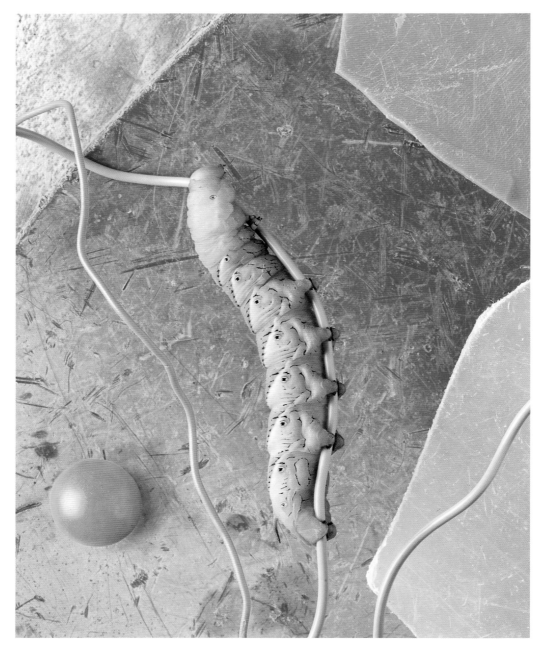

PLATE 45 *Manduca sexta*

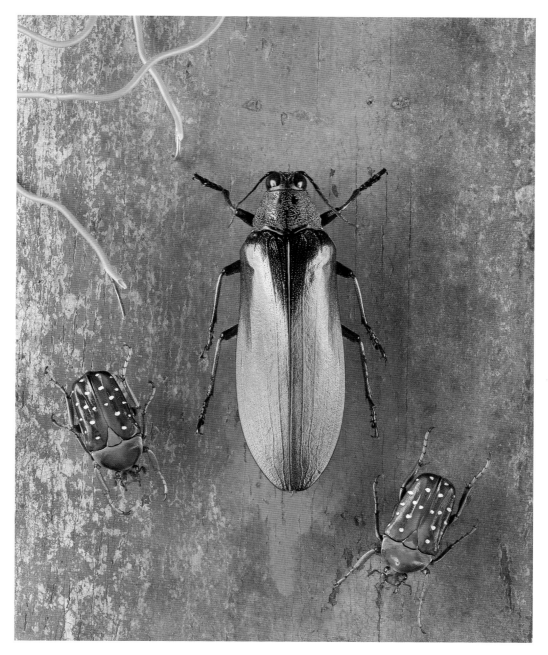

PLATE 46 — *Megaloxantha concolor & Stephanorrhina guttata*

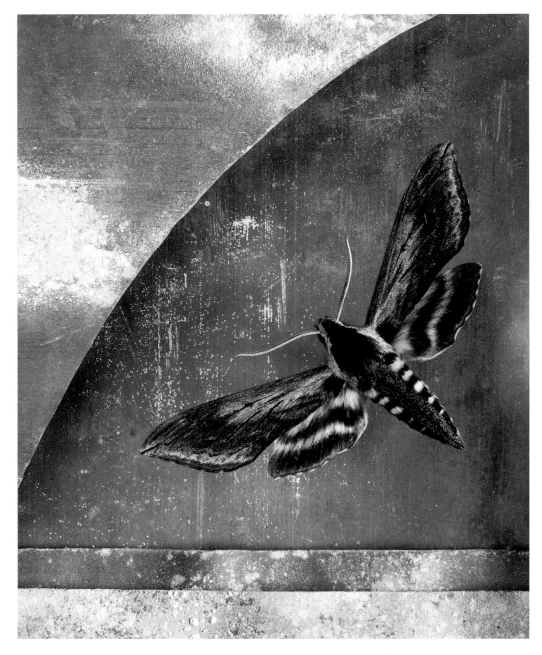

PLATE 47 · *Sphinx pereleganis*

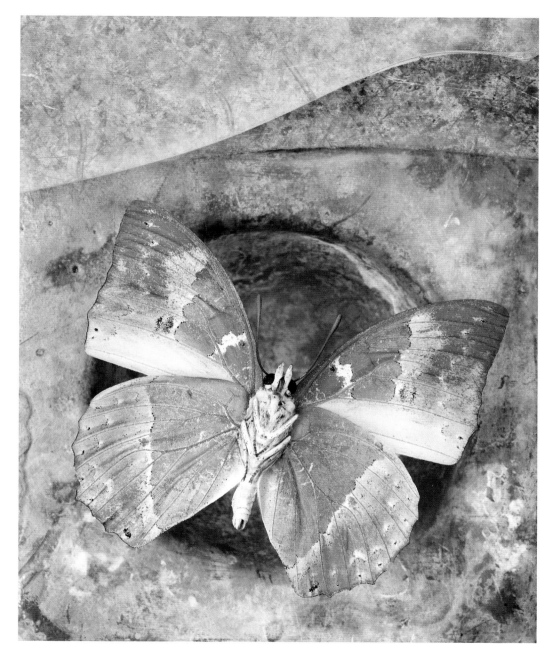

PLATE 48　　　　　　　　　　　　　　　　　　　*Charaxes eupale*

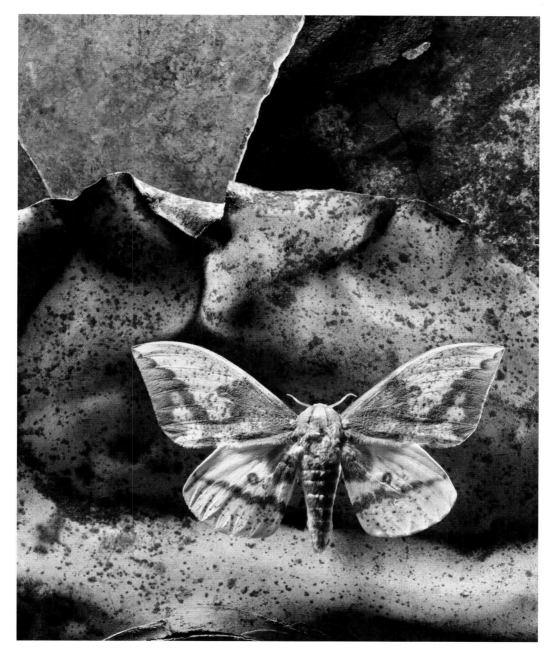

PLATE 49 *Eacles imperialis*

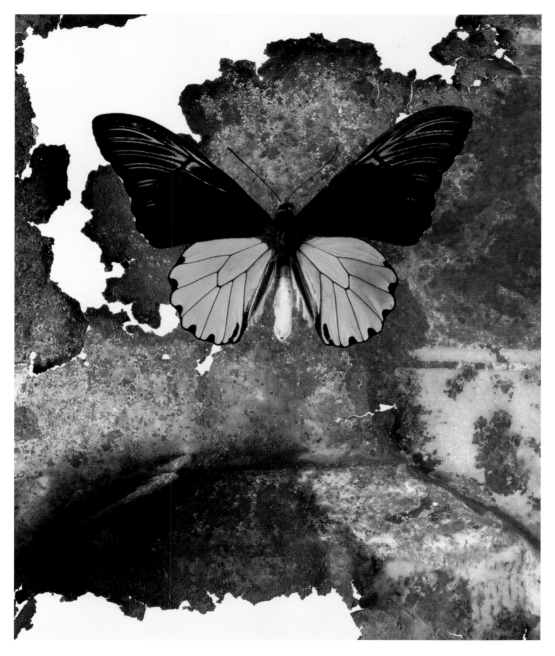

PLATE 50 *Triodes*

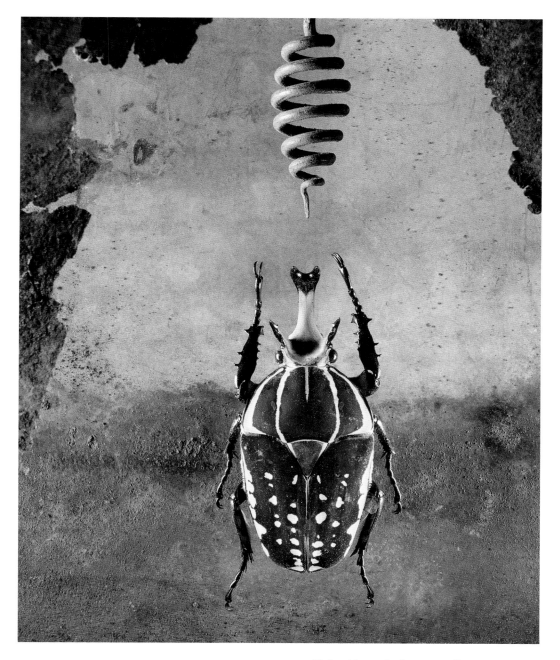

PLATE 51 *Chelorrhina polyphemus confluens*

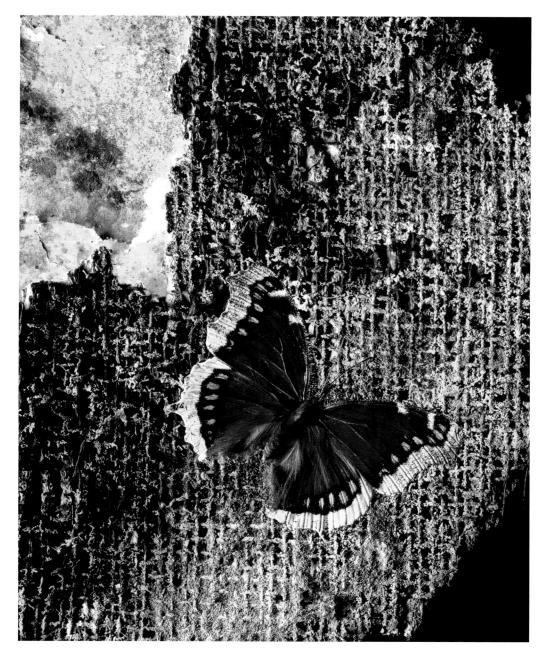

PLATE 52　　　　　　　　　　　　　　　　　　　*Nymphalis antiopa*

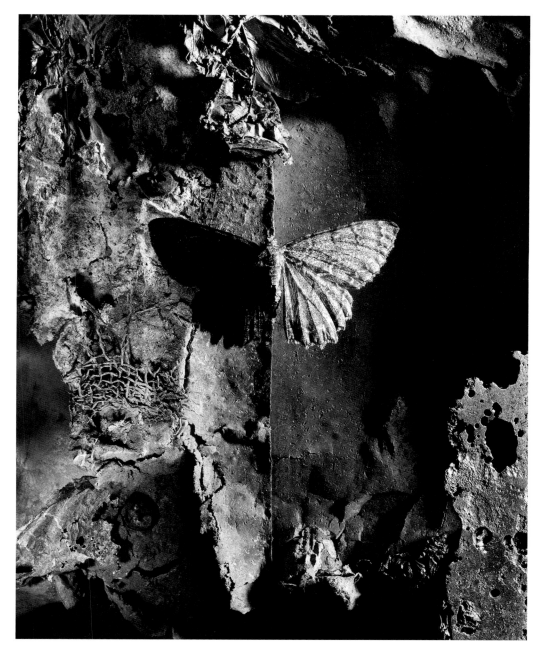

PLATE 53 Geometrid

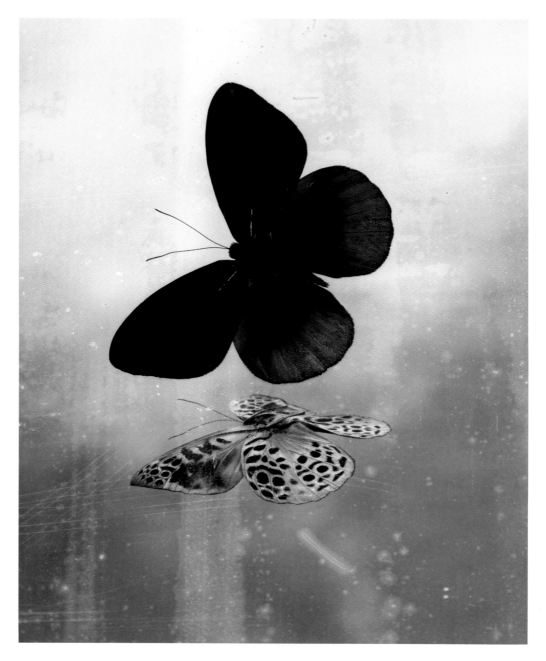

PLATE 54 *Asterope*

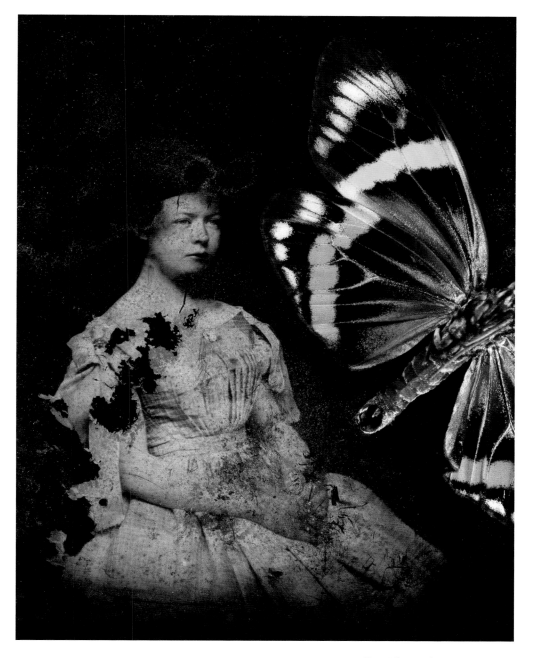

PLATE 55 Heliconidae: *Heliconius*

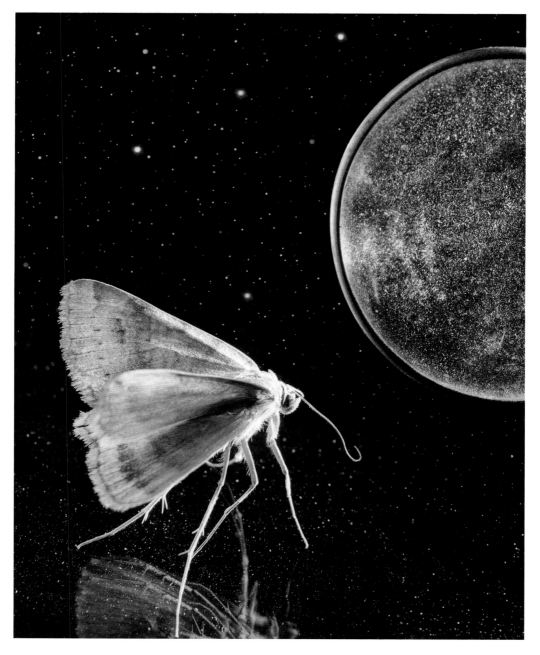

PLATE 56 *Noctuid*

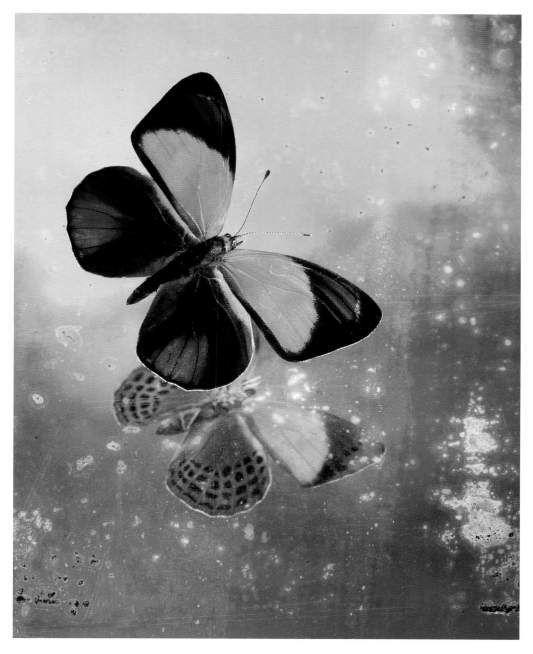

PLATE 57 *Asterope markii*

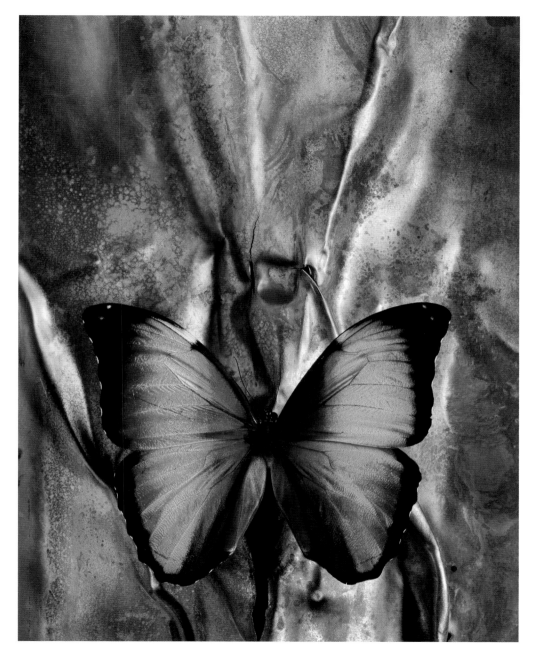

PLATE 58　　　　　　　　　　　　　　　　　　　*Morpho deidamia*

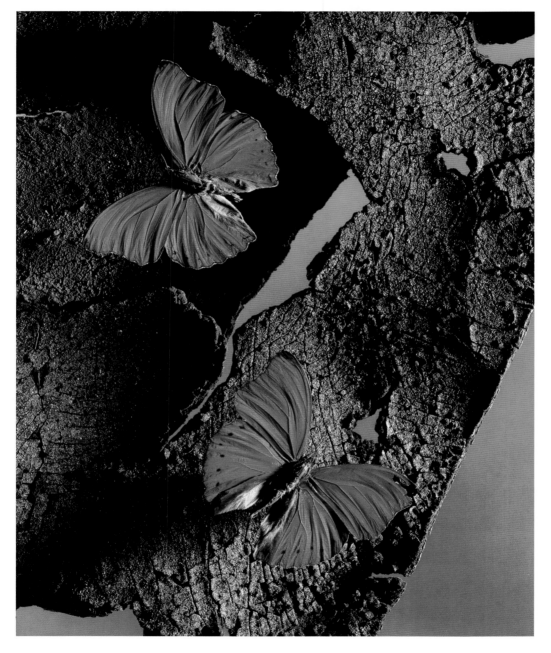

PLATE 59 *Cymothoe coccinata*

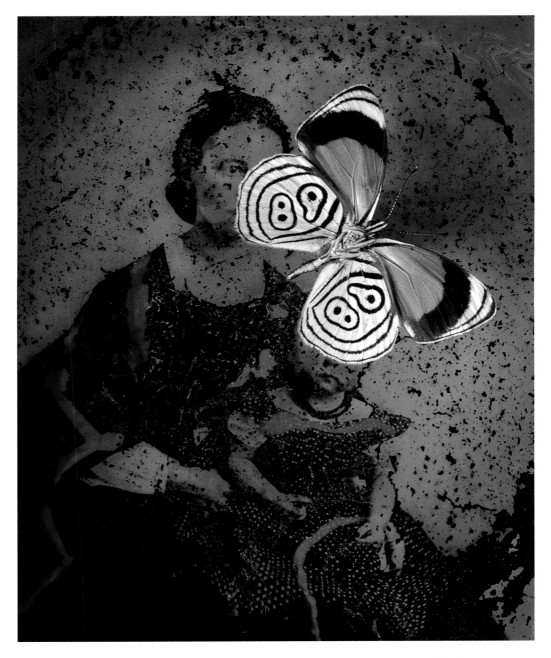

PLATE 60 *Diaethria*

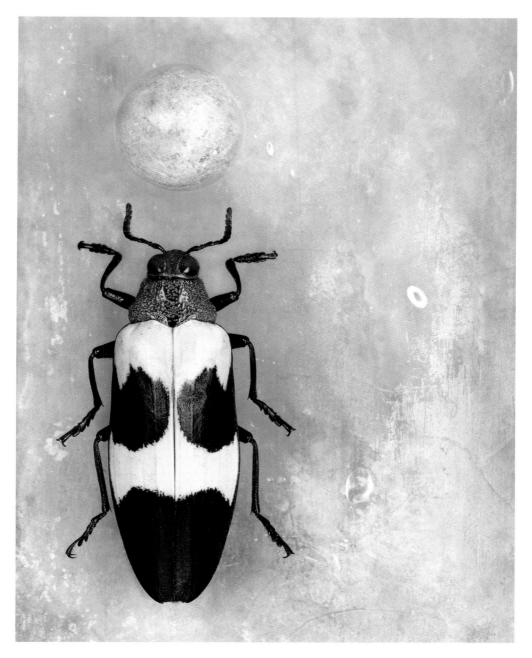

PLATE 61 *Chrysochroa bugueti rugicollio*

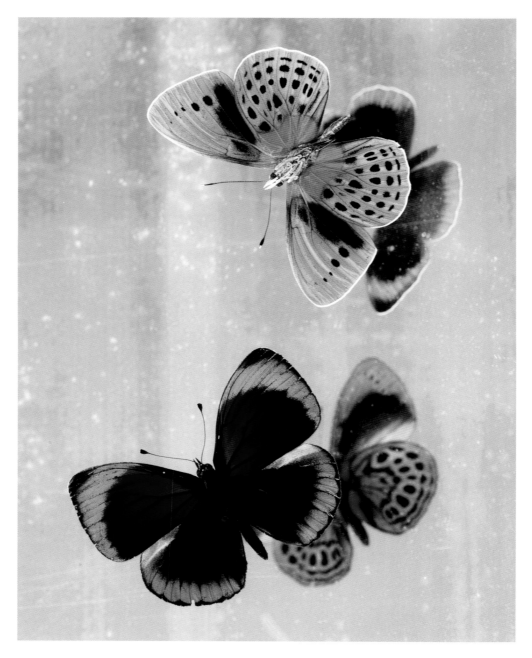

PLATE 62 *Asterope degandii & Asterope optima*

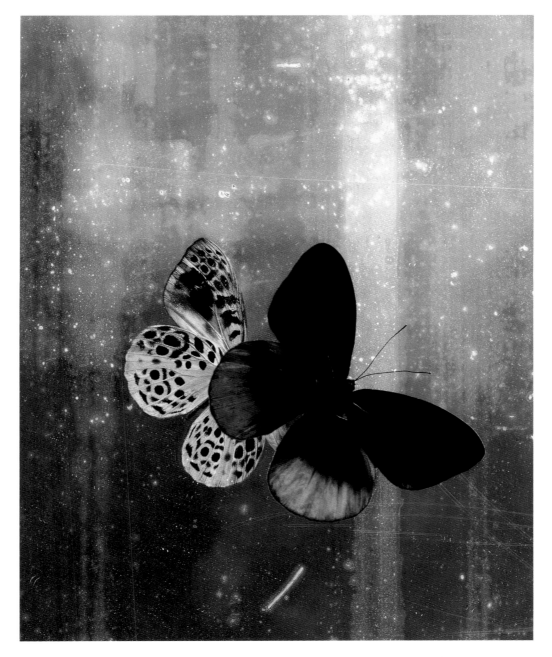

PLATE 63 Asterope

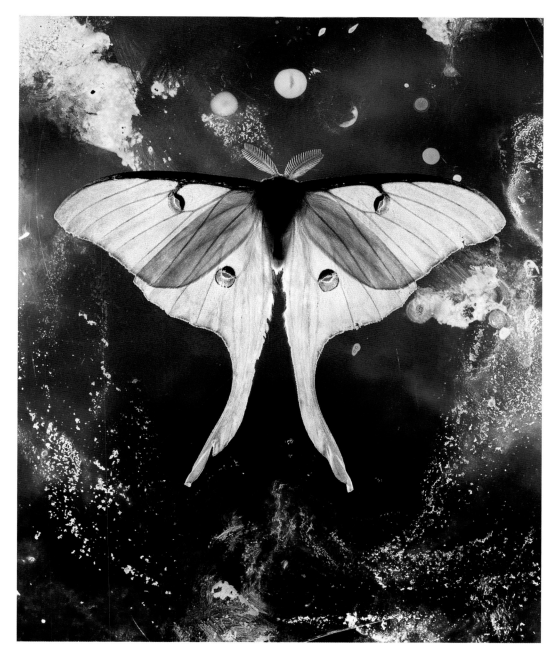

PLATE 64 *Tropea luna*

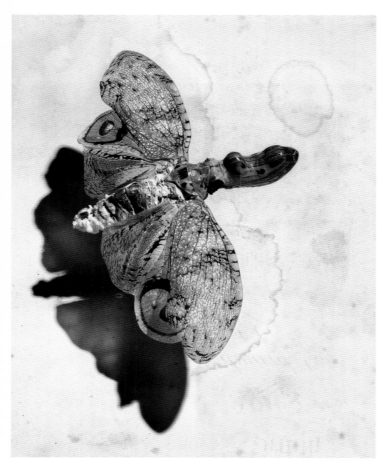

FULGORA LATERNARIA (LANTERN FLY)

PHILOSOPHY OF INSECTS

BY LINDA WIENER

"Wherefore we should not betake ourselves to the consideration of the meaner animals with a bad grace, as though we were children; since in all natural things there is somewhat of the marvelous. There is a story which tells how some visitors once wished to meet Heraclitus, and when they entered and saw him in the kitchen, warming himself at the stove, they hesitated; but Heraclitus said, 'Come in; don't be afraid; there are gods even here.'"

—ARISTOTLE, *PARTS OF ANIMALS*

Aristotle, writing in the fourth century BCE, exhorted his students to the study even of insects and worms because in not one of these animals is the "marvelous," "nature," or "beauty lacking." Aristotle searched for the divine through an intense and detailed study of the natural world. Heraclitus, his philosophical predecessor whom Aristotle invokes here as a kindred spirit, was in the presence of the gods at his kitchen stove. The warming fire of the stove is the same as that of volcanoes and the thunderbolt of Zeus. These men knew that attention to the commonplace, such as the fire in the stove and the insects that live all around us, gives us a key to the largest of human concerns—beauty and terror, nature and myth.

A first window into our relationships with insects is the names we give to them. For Aristotle, the Greek word *psyche* meant both butterfly and soul. *Psyche* retains the latter association in modern English. It is the root of our word *psychology*. Ever since I learned this double meaning, I have had the two concepts melded in my mind. I watch a small cloud of silvery blues in the Sangre de Cristo Mountains of New Mexico. They are tiny butterflies with iridescent blue wings; they flutter, land around a mud puddle, drink, and then take off on a small irregular flight, only to land again. They look like pieces of flying sky come down from the heavens. I think of souls come down to visit Earth in these delicate, erratic forms.

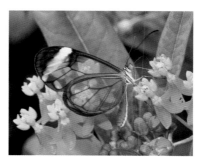

FIGURE 1

Other butterflies give different images. A migration of monarchs, hundreds of butterflies together, make their way to their overwintering grounds in a forest in Mexico. They are large, strong fliers. Bright orange patches edged in black, monarchs are conspicuous and poisonous to predatory birds and reptiles. They pass overhead in a flock, spread out over an October afternoon. Sometimes they come down to sip nectar; mostly they pass on, heading to their southern destination. These remind me of the souls of dead soldiers in the *Iliad* crowding all together down to Hades, having lost their young lives in a terrible battle.

One of a group of windowpane butterflies flits around a patch of lantana in Costa Rica (FIGURE 1). The Windowpanes' large wings are devoid of scales, and I see right through them. Sometimes, I have to look hard to see that an insect is there. The butterflies are visible, then invisible. The world appears through their wings. I look at the same patch of flowers, but through their wings it is strangely framed, teaching me to see that patch of flowers through a new medium.

The scientific names, the genus and species, come from Latin and Greek roots and are officially approved by the International Commission on Zoological Nomenclature, seated in London, which also approves the official common names and lays down the rules for naming. These names may describe the insect (*gracilicornis* for slender horn), give the location where it was found, honor a person—(real or mythical—*menander, ulysses, polyphemus*), or say something about its relationship to humankind—our joy in its beauty or the fear it inspires (pleasing fungus beetle, pernicious bamboo mealybug, death's head moth). The person who officially describes the insect and publishes the description (which tells how to distinguish it from other insects) gets to name it. There are rules: you cannot name an insect after yourself, and the scientific name must be spelled with Latin letters.

The Latin names are used everywhere in the world, but common names can be very different in different locations. Scientists tend to communicate using the scientific name, so as to be sure they are talking about

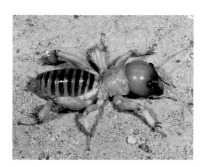

FIGURE 2

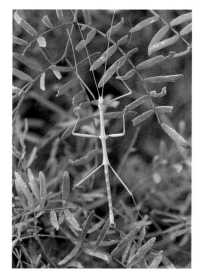

FIGURE 3

the same animal. However, we get a glimpse into local cultures and beliefs when we survey local names. The Jerusalem cricket (FIGURE 2; official common name, but no one seems to know why) is not a true cricket and is not found in Jerusalem. It is a cricket relative, common along the Pacific coast and in the southwestern United States. It is a harmless creature whose strange appearance has resulted in a dangerous and even mystical reputation. Anglo farmers call it "potato bug" because of its mostly unwarranted reputation for feeding on potato tubers. The Hispanic names are *niño de la tierra* (child of the earth) and *cara de niño* (child's face), referring to the head that is thought to resemble that of a human baby. The Navajo name is *wó see ts'inii*, or skull insect, a reference both to the appearance of the head and to the insect's reputation of being deadly poisonous. A New Mexico native recently told me how Jerusalem crickets hatch and then dig into the ground, remaining there for fifty years. When they finally emerge, you can hear them cry like a baby.

As a young girl, I was fascinated by insects, and my impression of these animals was that of the world of common names, which stressed the insects' relationship to humankind. Before I knew of scientific theories of nature, I observed that insects were about the beauty of an iridescent beetle, the mystery of a cryptic walking stick that was all but invisible on a twig (FIGURE 3), and the terror of walking by a nest of yellow jackets and having dozens of them shoot out and attack.

FIGURE 4

Later, as a scientist, I studied insects to find out facts about their life cycles, morphology, and behavior and how they interact with their environment. The theoretical backdrop of all this research was the theory of evolution through natural selection. According to this theory, all traits of organisms have evolved to promote the survival and reproduction of the individuals that carry them. Any trait that helps an organism survive and reproduce better than organisms that lack this trait will naturally be favored and therefore selected. This trait, if continuously selected, will eventually become fixed in the population.

There are a few other theories around, such as genetic drift, but natural selection is the concept that guides almost all biological research. Here is how it works: Take any trait in nature, for instance, the swaying behavior of mantids that mimics flowers or the spines on a caterpillar. Think of a reason why this trait helps the survival and reproduction of the insect. Test this through experimentation. If your theory does not hold up, think of another reason why this trait aids survival or reproduction and so on. This is productive and fun; it certainly solves some of nature's puzzles. However, the scientific view assumes that nature is only about utility. What happened to the beauty and mystery I experienced as a girl? I believe those naive responses revealed genuine aspects of nature that the method of natural selection is unable to illuminate. However, Jo Whaley's photographs help us see just these attributes—the aesthetic, philosophical, and mystical that, alongside natural selection, give us a fuller appreciation of the world.

These perceptions may be dismissed as anthropocentric, a projection of our desires and thoughts onto insects. It is impossible to *prove* that natural selection is unable to answer all questions about nature. Perhaps the right hypothesis has not yet been thought of or tested; perhaps we need

new equipment or methods of analysis and so have failed to find out why a particular trait is valuable to survival or reproduction of the organism. On the other hand, it is also impossible to *prove* that this utility is the whole answer. This leaves us free to put thoughts of proof aside and wonder what we might learn about nature by considering her from some other perspectives.

Our varied reactions to the world of insects may give us insight into the complex world of nature. Let us leave the avenue of utilitarian thinking for now and further pursue some of these alternative roads; insects are an ideal vehicle to take us on these paths. Consider the subject of mimicry. Some harmless flies look like dangerous bees. A group of unrelated poisonous butterflies may all look very similar; some insects look like leaves (FIGURE 4), twigs, thorns, or flowers or have spots that resemble bird eyes. All of these appearances may help them escape the notice of potential predators or prey or deter predators from attacking. These phenomena are well known from textbooks, popular science reporting, and nature shows. However, the stories that are told are often not as solid as they seem.

Many flies, beetles, and moths resemble bees or wasps. This resemblance can protect them from predators that have learned to associate a striped pattern with a painful sting. However, predators that have learned how to avoid the stings will preferentially seek out such insects. If the harmless bee and wasp mimics are more abundant than the stinging insects that serve as their models, something that happens quite often, the mimic receives little or no protection from its mimicry.

A tiny picture wing fly emerges from a gall on a rabbitbrush plant; the pattern on its wings remarkably resembles a jumping spider (FIGURE 5). The fly moves its wings so as to mimic the actions of a male spider making a territorial threat to another male spider. Laboratory research has shown that a male jumping spider will be deterred by this combination of pattern and movement and avoid the fly instead of trying to eat it. However, years of looking for such spiders on the rabbitbrush in New Mexico have never yielded the male spiders that the flies are supposed to be mimicking, and therefore, one wonders how and why this remarkable mimicry is sustained.

FIGURE 5

Does a bird really think that the miniature, inflated head of the lantern fly is an alligator that will eat it up? How much like a leaf does an insect have to be before it is invisible to its predators (FIGURES 6 & 7)? Might other forces be at work here, alongside natural selection, to shape the forms and behaviors of these insects?

Roger Caillois, a French philosopher, explores these questions in his daring book *The Mask of Medusa*. After reviewing many examples of mimicry among insects and finding a "superabundance of mimicking factors," an "excess of similarity," and an "aimless delirium of perfection," he says,

> if I dwell on the inexplicable convergence which, in one and the same area, makes butterflies of widely separated species almost indistinguishable, it is to try and establish the fact that in the world of living things there is a law of pure disguise: that there is a leaning towards the act of passing oneself off as something or someone else, clearly seen, indisputable and in no way to be accounted for by any biological necessity connected with the struggle for existence or natural selection. How this is done, its mechanism, remains a mystery.[1]

Henri Bergson, an earlier French philosopher, takes up the question of insects in his book *Creative Evolution*. He writes of the two great tendencies of nature that have resulted in insects with their instincts on the one hand and humans with their creative intelligence on the other. Insects, Bergson writes, teach us about "the habits of inert matter." He was interested most in the perfection of instinct in insects, how the body of an insect can contain a tool such as the weapon of a sting or the glands that make wax—and possess innate knowledge of the tool's use. The most intelligent animal, man, may need weapons or building materials, but he makes them himself out of the matter he finds and fashions. Both achieve the same ends, but insect instinct "implies the knowledge of matter" while human intelligence "is knowledge of form." Often, intelligence is seen mixed with instinct, even in insects. We witness a spider figuring out how to anchor her web or a hunting wasp trying to carry her prey into a burrow. Human intelligence is also mixed with instinct, as revealed by watching a young child learn to walk. Instinct and intelligence are, for Bergson, the two great tendencies; insects and humans show the current apex of each tendency.[2]

FIGURE 6

FIGURE 7

I want to take this line of thought a step further. Whaley's images suggest that also in regard to art, humans and insects have similar goals. The wings of a butterfly or moth, in their form and their use of color, line, and composition, are artful to a high degree. By removing the insects from the natural environments in which they evolved, and displaying them in constructed environments, their aesthetic qualities come to the forefront. These environments reveal the insects as pieces of art, produced without need of consciousness, out of living matter. The photographs in this book are a collaboration between unconscious living matter and the creative human imagination. The two suggest and augment each other. They speak to a drive toward aesthetics at the heart of nature. We see the forces of nature come out on the surface of an insect body. Artist and insect are pointing us in the same direction: to the basic aesthetic drive in nature. Insect bodies often go beyond what is necessary for survival; they are an expression of the extravagance and abundance of nature alongside the utilitarian needs.

We can combine Bergson's and Caillois's lines of inquiry. Caillois asks why, if insects "transform parts of their own organisms into specialized tools—hooks, knives, pincers, scissors, borers, syringes or siphons—they, by means of the incredible chemistry of necrosis, produce on themselves a rich and distinctive display," like painting in the human world.[3]

Once we apply the criteria of art criticism to a butterfly wing, we easily see it from an aesthetic point of view. Although the butterfly is not consciously producing this effect, it is showing the principles of color, form, and harmony that are inherent in nature on its body. One of the functions of an organism, aside from getting food and reproducing, can be to show forth these principles.

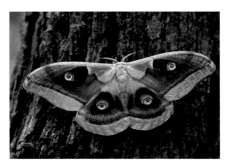

FIGURE 8

Caillois then moves beyond questions of aesthetics, finding in the eyespots of mantids and moths an expression of "an imaginary terror not corresponding to any real danger" and "the strange and fantastic" that are inherent in nature.[4] He connects the eyespots of insects with human myth

and sorcery. The eyespots on a moth wing (FIGURES 8 & 9), he claims, are the insect equivalent of the evil eye in human societies, with much the same function. They are akin to the eyes painted on a ship's hull or a shield, meant to inspire a nameless terror. This meaning is understood by a bird predator in the natural realm as well as in human societies.

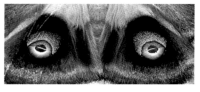

FIGURE 9

Just as shamans and sorcerers of legend are able to make themselves invisible and shape-shift, so too can they give the evil eye. The cloak of invisibility, so common in myth and folklore, is also ubiquitous in the insect world. A grasshopper disappears into the rocky soil; a butterfly folds up and becomes invisible among the dead leaves on the ground. Caillois points us to the eyespots so common on moths and butterflies, as well as on grasshoppers, mantids, and other insects. So frequently, these two traits of shamans and sorcerers are also combined in the insect. The moth is invisible on the trunk of the tree; its forewings blend into the bark. When disturbed, it flashes the prominent eyespots on its underwings, startles, and then is gone. These eyespots need not literally fool by making a potential predator think it has encountered a large bird, but are, according to Caillois, signs of a universal terror, not necessarily associated with real danger. Thus, we see expressed on insect bodies a primal horror as well as a primal drive toward beauty. These two tendencies are the very basis of life itself; the creative beauty of birth and young life and the crumbling into decay and death.

A parallel example of this convergence of art and nature comes from birdsong. Speculative philosophy has pointed us to the music of the spheres in which harmony and music are seen as expressing the deep structure of the universe. This is manifest in the motion of the planets and in the songs of birds. Birdsong is utilitarian insofar as it is used to attract mates or protect territories. But birdsong is often more than is strictly necessary. Birds sing outside the mating season and when they are not defending a territory. Could they sing for the joy of it? David Rothenberg, in his book *Why Birds Sing*, talks about an experience making music with a laughing thrush. His duet with the bird shows that birds can respond to human music with more than mimicry; they can create music and make music

along with us. Just as with the beauty of insects, the song of birds has both utilitarian and extra-utilitarian functions. Clearly, aesthetic principles can be used in the service of reproduction, but that is no proof that beauty has evolved for that purpose alone. Aesthetics seems to be a basic principle of nature. The bird "knows" musical principles and can use them in the service of territorial display or reproduction as well as in the playful enjoyment of musical creation. The utilitarian uses of music may be derived from a broader and more primal aesthetic principle in nature.[5]

In *Creative Evolution*, Bergson suggests that much of nature can be comprehended in terms of musical themes and variations. The many different ways that hunting wasps subdue prey show a broad theme (paralyze prey, but don't kill them). The way each particular kind of hunting wasp deals with its particular kind of prey is a variation on this theme. The theme itself, he says, "is everywhere and nowhere."[6] Mimicry would be another theme, the theme of looking like, or taking on characteristics of, some other form in nature (FIGURE 10). Just as insects can display aesthetic principles on their bodies, humans can display these same principles in the art they create. Insects mimic other parts of nature just as humans mimic animals in Native American dances, clothe themselves in the pattern of jungles during military maneuvers, or assume alter egos during masquerade balls and in stage and film. This can all be done simply or elaborately, convincingly or badly. The meaning of mimesis, both in insects and in humans, is manifold. It can indeed protect from observation, but it also serves to take on the power of another creature, honor another, have fun, escape from your own given identity, and any combination of these uses. It is both a spiritual and a physical endeavor, a primal thrust of Nature.

This convergence of the aesthetic or mythological as expressed unconsciously in matter and its exploitation by the human creative imagination has not gone unnoticed by writers. The gold bug in Edgar Allan Poe's story of that name represents a new and fantastic species of beetle, boundless wealth, and death. The death's head moth in Thomas Harris's *Silence of the Lambs* is a representation of the metamorphosis, the literal changing of his skin, that the antihero seeks and the death in which this seeking results. In A. S. Byatt's *Morpho Eugenia*, the butterflies are beautiful creatures of the day that evoke romantic notions of love, while moths provoke horror and all the unconscious hidden recesses of the human sexual psyche.

I realize through these reflections that, for me, the world of my youthful experience of insects gave me a first glimpse into the manifold truths that nature has to teach. It gave me the impetus I needed to set out on various paths to understanding nature. Watching a grasshopper flash its colorful back wings and then disappear into the landscape starts the budding scientist on the road to scientific questions involving predator avoidance and reproduction. Seeing the fabulous forms and colors of the *Ornithoptera* butterfly inspires the artist to produce something beautiful, and the future mystic may begin his contemplation of Nature's secrets by watching a nest of ants.

That which we express in our music, art, and philosophy we can recognize also in matter, both inorganic and organic. It takes a lifetime of devotion to discover these secrets.

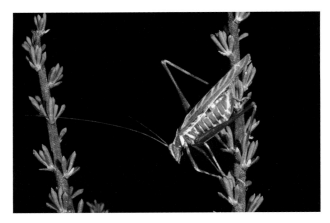

FIGURE 10

1. Roger Caillois, *The Mask of Medusa*, trans. George Ordish (New York: Clarkson Potter, 1964), 87.
2. Henri Bergson, *Creative Evolution*, trans. Arthur Mitchell (Lanham, MD: University Press of America, 1983).
3. Caillois, *Mask of Medusa*, 38.
4. Ibid., 104.
5. David Rothenberg, *Why Birds Sing: A Journey into the Mystery of Bird Song* (New York: Basic Books, 2005).
6. Bergson, *Creative Evolution*, 171.

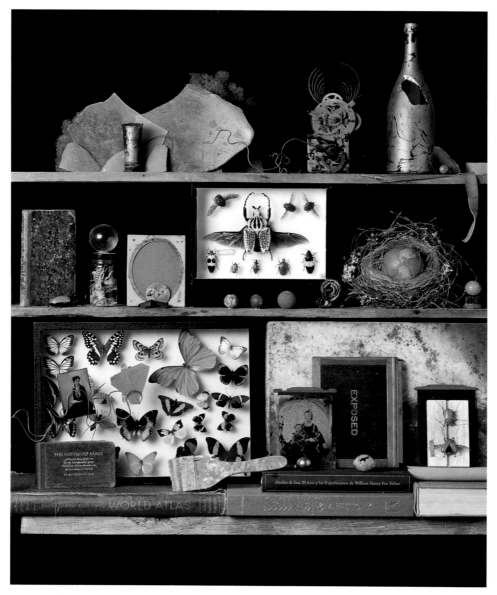

FIGURE 1

NOTES FROM THE STUDIO
BY JO WHALEY

There is a flicker of movement caught by the corner of my eye. I pause long enough from one of those questionably imperative tasks of the day to ponder a minuscule, seemingly insignificant insect. If one carefully looks at the overlooked, a whole world presents itself. The appearances of insects range from those of menacing aliens to those of creatures of ornamental beauty. Their ingenious structures and designs are unique visual qualities that inspire awe. As an artist I find great aesthetic lessons in their strategies of mimicry, camouflage, and metamorphosis. Delightfully distracted, I am caught in the butterfly net of their visual forms and held absolutely mesmerized with wonder.

The photographs in this book are fantastic field illustrations. While the insects in these images are real, the backgrounds are imaginary altered habitats of my devising. Inspired by the old dioramas found in natural history museums, the pinned insects are arranged in constructed environments. The studio where I create the images is as much a theatrical scene shop as it is a photography studio. The prop room looks like an eighteenth-century cabinet of curiosities, in that it is filled with specimens of natural history and visual oddities of manufacture (FIGURE 1). I use free association and intuition to make decisions about arranging the insect with a particular backdrop. Looking at color, shape, and form, I move the elements about until the magic of the image appears. Lighting the scene is challenging as the sets are only about five by seven inches across with a depth of about an inch and a half. Yet the studio lighting is key to breathing a spirit into these pinned specimens and unifying the disparate elements within the *mise-en-scène*. Finally, the performance of the image is concluded with a single click of the camera's shutter.

The difficulty with the still-life genre is that one has to animate the inanimate. The phrase "still life," after all, comes from the Latin *natura mortalis*, or dead nature. My approach is to consider the still-life set as a

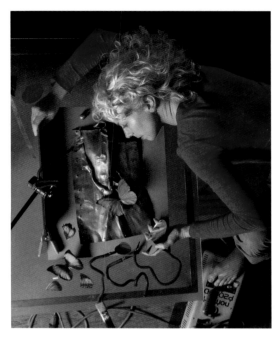

FIGURE 2

theatrical stage, where the backdrops are fabricated and the objects are positioned to create a visual dialogue (FIGURE 2). In designing the set, I take my lead by considering the aesthetics that are apparent in the insects themselves. Early in my career, I earned a living by working as a scenic artist. In the theater, I learned prop construction and theatrical painting techniques and the transformative quality of lighting that can infuse a scene with a specific emotional mood. Most important, I learned the lessons of artifice and illusion, embracing the concept that theater is the lie that tells the truth.

 Each element in a still life contributes to the narrative of the image. The staged sets for these insects use cast-off materials from urban production, which have been partially reclaimed by nature. These include metal that has gone through fire, glass that has become oxidized and iridescent in the earth, plastic that has been pitted by the sea, and paper that is foxed by microorganisms. These found objects are chosen for the visual poetry written in their deterioration and imperfection. In this work, the animating

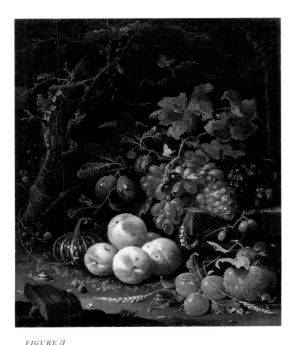

FIGURE 3

FIGURE 4

spirit is the Japanese aesthetic known as *wabi-sabi*, which celebrates the state of decay as a spiritual reflection of life itself and above all reveres nature. As opposed to the ancient Greek aesthetic of ideal beauty, with its regular proportions and flawless perfection, *wabi-sabi* sees beauty emerging from ugliness, such as the painterly transmutation that occurs when a piece of metal rusts. Likewise, some insects may seem repulsive at first, but close observation reveals their expressive power.

Manufactured objects and insects have appeared together before in art history. In the European iconography from the sixteenth to the eighteenth centuries, the insect in still-life painting symbolized the transient nature of all life, as an insect's life span is literally short and some insects assist in the deterioration of matter. These paintings were cautionary tales with their sumptuous displays of earthly bounty and material wealth, while characteristically including a clue to mortality, such as a skull or an architectural fragment and inevitably a crawling insect (FIGURES 3 & 4). They warned that whatever humans create is in fact fleeting and that all wealth is mere

vanity in the face of death. Ultimately, decay and entropy take their toll on every human endeavor. This classic theme of *vanitas* is carried forward in my photographs, but with the insect featured as the main subject. To reinforce this concept in the work, the specimens are depicted not in their actual size, but rather their scale is large, approximately the size of a human head. The viewer thus confronts the insect on a one-to-one relationship, as an equal, calling into question the perceived human dominance over nature.

In my photographs, the natural specimens are combined with the detritus of our manufacture to mirror my observations of the limbo between the natural habitat and the one we have altered, sometimes beyond the point of recognition. Consider the urban environment of any large contemporary city, where trees emerge from concrete and where polluted skies can be glimpsed only through vertical canyons of glass and steel and where the stars are no longer visible, in favor of artificial light. The beauty of a butterfly's wings belies the reality that it is often toxic. As part of their defense, many of the more visually striking insects are literally pretty poison to a predator. The opulent objects and lifestyles of urban culture unfortunately have a toxic impact on the environment. But the seduction, like the beauty of butterfly wings, is hard to avoid.

The interplay between the natural world and urban culture is illustrated by the phenomenon of industrial melanism. While controversial, the scientific theory that some insects have in fact taken on protective coloring to camouflage themselves in an industrially altered habitat is an apt metaphor for our current environmental predicament.[1] The case often illustrated in textbooks is that of *Biston betularia*, or the peppered moth, that occurs in both light and dark forms within the same species (FIGURES 5 & 6). The light-colored moth predominated in the population, presumably because it blended with the white birch trunks and the light lichen on oak trees. However, decades after the start of the Industrial Revolution,

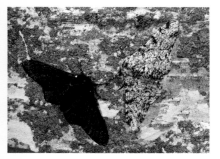

FIGURE 5

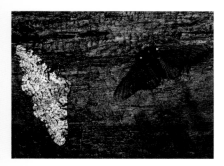

FIGURE 6

it was observed in Manchester, England, that the dark form of the peppered moth began to predominate the population, as pollution from the surrounding factories killed the lichen and covered the birch trees with soot. The concept of industrial melanism is a starting point for many of my photographs, which are imaginary interpretations of the scientific theory.

The inability to control what human manipulation of nature unleashes is wonderfully described in popular culture. Mary Shelley's *Frankenstein* continues to captivate. The postwar Japanese films *Godzilla* and *Mothra* reflect, in science fiction form, the terrors of nuclear power unleashed, as experienced in Hiroshima and Nagasaki. In those films, gigantism is the result of humans overstepping the boundary of natural order. Formally benign creatures become threatening and take on supernatural powers.

Likewise, the large scale of my photographs reveals the more menacing visual aspects of insects that often coexist with their ornamental beauty. Evidence of gigantism does exist in the fossil records. Three hundred fifty million years ago there was a great dragonfly, *Meganeura monyi*, with a gargantuan wingspan of thirty inches. It is theorized that *Meganeura* was able to fly only because the atmosphere at the time contained more oxygen than the present 20 percent. Insects have the ability to evolve quickly, despite climate changes. Ironically, humans have no such ability for rapid adaptation, and perhaps as a species we are doomed to be more fragile than insects.

Like moths attracted to the light of a flame only to perish in that flight, I wonder if we, too, are tied to self-destruction through a drive toward greater technological heights. Conversely, we may be able to use technology and our creativity to become more integrated with nature. As always, the future is uncertain. Art and science are not so diametrically opposed. The practice of both begins with the intense observation of nature, which in turn sparks the imagination toward action. Just pause long enough to look. There is a flicker of hope fluttering in the collective peripheral vision.

1. Judith Hooper in her 2002 book *Of Moths and Men* (New York: W. W. Norton) called into question the methodology of the experiments conducted by H. B. D. Kettlewell and thus his theory of industrial melanism. The fact remains that the proportion of the dark form of the peppered moth in the industrial areas of England was observed to increase significantly. To this day, it is not clear why this happened.

— LIST OF ILLUSTRATIONS —

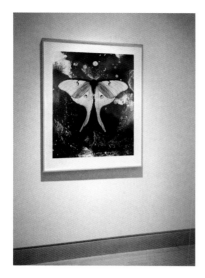

TROPEA LUNA, INSTALLATION VIEW, ROBERT KOCH GALLERY

Plates 1–64 are all large chromogenic photographs created in the first decade of the 21st century

SPECTACLE OF NATURE by Debra Klochko

Figure 1: Domenico Remps, *Cabinet of Curiosities,* late seventeenth century, oil on canvas, 39x53 inches. Credit: Museo dell'Opificio delle Pietre Dure, Florence

Figure 2: Engraving of a Flea, *Micrographia,* Robert Hooke, 1665

Figure 3: Hand-colored engraving of a fly, c. 1600

Figure 4: Ernst Haeckel, *Moths* (Tineidae), engraving c. 1890

Figure 5: Unidentified Photographer, *Butterfly Collector,* c. 1850, Daguerreotype. Credit: George Eastman House

Figure 6: Willam Henry Fox Talbot, *Insect Wings,* (negative and positive) 1839–1841, Calotype and salted paper print. Credit: National Media Museum/Science and Society Picture Library, London

Figure 7: Anna Atkins, Carix (America), c. 1850 Cyanotype. Credit: George Eastman House

Figure 8: Sir William Jardine, *The Naturalist's Library,* Plate 24, 1843

Figure 9: Jo Whaley, *Cithaerias,* 30x24 inches, chromogenic photograph, 2000

PHILOSOPHY OF INSECTS by Linda Wiener

Fulgora laternaria (Lantern Fly), photograph, Jo Whaley, 2007

Figure 1: Michael Holland, *Cithaerias,* windowpane butterfly

Figure 2: David Lightfoot, *Stenopelmatus fuscus,* Jerusalem cricket

Figure 3: David Lightfoot, *Mesquite Walking Stick*

Figure 4: David Lightfoot, *Leaf Katydid*

Figure 5: David Lightfoot, *Fly*

Figure 6: David Lightfoot, *Crested Grasshopper*

Figure 7: David Lightfoot, *Dead Leaf Grasshopper*

Figures 8 & 9: David Lightfoot, *Oculea Silk Moth* & detail

Figure 10: David Lightfoot, *Chaparral Katydid*

NOTES FROM THE STUDIO by Jo Whaley

Figure 1: Jo Whaley, *Studio Prop Shelf,* 2007

Figure 2: Greg MacGregor, *Studio Portrait of Jo Whaley,* 2007

Figure 3: Abraham Mignon, *Still Life with Fruits, Foliage and Insects,* c. 1669, oil on canvas, 23x19 inches. Credit: Minneapolis Institute of Arts, Gift of Bruce B. Dayton

Figure 4: Details, Abraham Mignon, *Still Life with Fruits, Foliage, and Insects*

Figure 5: Kim Taylor, *Peppered Moth (Biston bettularia)* normal & melanic forms on a birch trunk

Figure 6: Kim Taylor, *Peppered Moth (Biston bettularia)* normal & melanic forms on a charred tree trunk

— *ACKNOWLEDGMENTS* —

My first expression of gratitude is to my Muses, the marvelous beetles, butterflies,
and moths that have been my inspiration and have guided my imagination.

There have been many wonderful *Homo sapiens* who have contributed to the formation
of this book and to whom I am truly grateful.

Alan Rapp
My editor at Chronicle Books whose support of this project encouraged
me to push my own artistic parameters and whose gracious guidance
helped navigate me through the publishing process.

Deborah Klochko
Who over the years as a curator and museum director has given me a broader
conceptual and historical context in which to consider photography.

Linda Wiener
Whose conversations on entomology greatly expanded my conception of nature.

Susan Winter
Writer and filmmaker who encouraged me to rethink, rewrite, recast, and revise.

Carlan Tapp
Photographer, friend, and colleague, who has launched me into the digital realm.

Brett MacFadden, Darius Himes, and *Elsa Kendall*
Brett as the co-designer of this book, Darius as editor of the Photo-Eye book list, and Elsa as designer,
all raised my awareness of the photography book as art form and guided me with advice.

Ron Cauble
Entomologist and owner of The Bone Room, Berkeley, CA,
where many of my specimens were acquired.

I would also like to acknowledge and thank the following gallery dealers and museum curators
who have supported and exhibited my work over many years:

Joseph Bellows of Joseph Bellows Gallery, La Jolla, CA.
Rixon Reed and *Vicki Bohannon* of Photo-Eye Gallery, Santa Fe, NM.
Holden Luntz of Holden Luntz Gallery, Palm Beach, FL.
Lisa Sette of Lisa Sette Gallery, Scottsdale, AZ.
Robert Koch and *Ada Takahashi* of Robert Koch Gallery, San Francisco, CA.
Kate Ware of the Philadelphia Museum of Art, PA.
Bonnie Earls-Solari, an independent curator and art advisor, San Francisco and Hawaii.

My thanks to *J. D. Talasek*, of the National Academy of Sciences, Washington, DC, for curating
the inaugural exhibition of the photographs, which accompanies this book.

Finally, I wish to recognize the stimulating community of artists and friends who are my partners in
a creative life. Among them are *Doug Whaley*, beloved brother and architectural blacksmith,
who continues to inspire me, and *Greg MacGregor*, photographer, husband, and former rocket scientist,
whose wit and intellect encompasses both art and science.

— CONTRIBUTORS —

Photographer **Jo Whaley** has exhibited for more than twenty-five years, and her work is held in the permanent collections of numerous institutions and museums, including the Los Angeles County Museum of Art, the Philadelphia Museum of Art, and the George Eastman House. A recipient of a National Endowment for the Arts Award, she resides in Oakland, California, and Santa Fe, New Mexico.

Santa Fe–based entomologist **Linda Wiener** has acted as a consultant for the Queen Sirikit Botanic Garden in Chiang Mai, Thailand, and for the Zapatista communities in Chiapas, Mexico. Her research interests include abundance and diversity of butterflies and spiders, and the interface between the practice and philosophy of science.

Director of the Museum of Photographic Arts in San Diego, California, **Deborah Klochko** has more than twenty years' experience in photography museums as an educator, director, and curator of thirty exhibitions. She is the coauthor of *The Moment of Seeing: Minor White at the California School of Fine Arts* and *Ichthyo: The Architecture of Fish* (both published by Chronicle Books).

DELTA COLLEGE LIBRARY

DISCARD

TR 729 .I6 W53 2008
Whaley, Jo.
The theater of insects
6/2009